THE *Accidental* HOMESTEADER

KATHI LIPP

TEN PEAKS PRESS®
EUGENE, OR

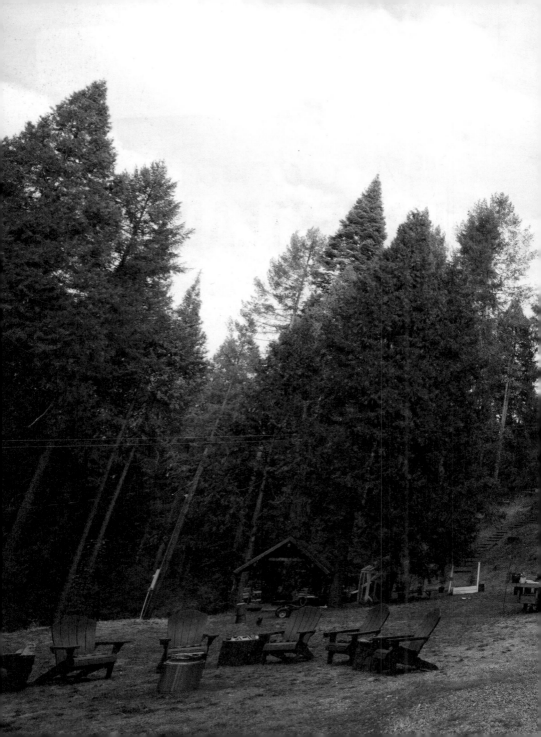

Published in association with Books & Such Literary Management, www.booksandsuch.com.

Cover and interior design by Dugan Design Group
Photo on page 174 by Kathi Lipp, all other photography by Jay Eads

The Next-Day Chili recipe and the Homemade HE Laundry Detergent are taken from
Ready for Anything by Kathi Lipp. Copyright © 2020 by Kathi Lipp. Used by permission
of HarperCollins Christian Publishing. www.harpercollinschristian.com

TEN PEAKS PRESS is a federally registered trademark of the Hawkins Children's LLC.
Harvest House Publishers, Inc., is the exclusive licensee of this trademark.

**TEN PEAKS
PRESS®**

The Accidental Homesteader

Copyright © 2023 by Kathi Lipp
Published by Ten Peaks Press, an imprint of Harvest House Publishers
Eugene, Oregon 97408

ISBN 978-0-7369-7700-5 (pbk.)
ISBN 978-0-7369-7701-2 (eBook)

Library of Congress Control Number: 2022948707

Printed in Colombia

23 24 25 26 27 28 29 30 31 / NI / 10 9 8 7 6 5 4 3 2 1

THE ACCIDENTAL HOMESTEADER

Or how two Silicon Valley city folks gave up the hustle and found their place in the mountains with luck, community, and a chicken who thinks she's a rooster.

You may be thinking to yourself that homesteading is not in your immediate future. No problem. We didn't either.

But sometimes, you have to go where life (and God) takes you. And sometimes, that means you end up on the top of a mountain with no internet access and the closest chain grocery store over an hour away.

If you're wondering if this book is for you, let me tell you who it's for:

1. Anyone intrigued by homesteading

I had read a number of books about homesteading, local food, gardening, raising chickens, and cooking from scratch, all without ever thinking about actually diving headfirst into the homesteading lifestyle. But here we are.

If you've been "homesteader-curious," I want to help you explore some of those themes without you necessarily deciding to immediately go grab some baby chicks at the nearest grain and feed store. You can practice some aspects of the homesteading lifestyle no matter where you live.

2. Anyone who has been wanting to make a big change in their life but is worried it's too late

Roger and I were both in our fifties when we decided to move to the mountains and start a garden, build a greenhouse, raise chickens, and only go into town once a week, like Pa on *Little House on the Prairie*.

3. Anyone who has felt God calling them in a different direction than what is expected

Maybe your kids think you're crazy. When we had two houses and were trading off living in one and renting the other on Airbnb, our daughter Amanda told her friends that her parents were having a "homeless midlife crisis." I would be offended, but that was pretty accurate.

The good news is that you don't have to justify doing something different with your life. We went from wanting a one-room cabin we could use on holidays and weekends while living in Silicon Valley, to moving to the mountains full-time to run a writers' retreat center in a town that most people in our state have never heard of.

When you're following God, life is never boring.

4. Anyone who wants to create a simpler (not necessarily easier) life right where they are

Everything we do here on the mountain is simpler. Not easier. Not one decision we've made has taken us in the "easy" direction. But man, life is a lot better here on the mountain. In every way I could imagine.

Whatever your reason, I hope I will be able to lend you a little bit of inspiration and, if you decide to do something different with your life, a little bit of moxie.

We've never regretted our move to the mountain. You don't regret when the Lord leads you into adventure. Even when others may question your sanity—daily.

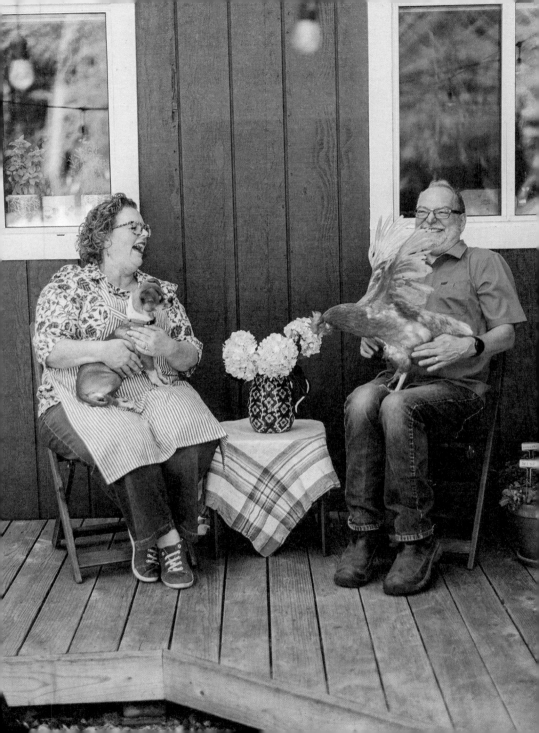

❧ CONTENTS ❧

Introduction

Homesteading [hŌM-sted-ing]

1. an act or instance of establishing a homestead

**2. the act of loving where you live so much that you
actively ignore the fact that your house is trying
to kill you on a regular basis**

Had anyone mentioned that as homesteaders, we would be evacuees for almost a month because of a fire, be trapped in our house for weeks on end during winter storms, and have a tree fall between us as we slept in until almost six thirty in the morning, this might not have been the life change we chose to make.

As the house has made abundantly clear, we had no business moving to the mountains. And that wasn't the plan, anyway.

One Fourth of July weekend, my husband, Roger, and I rented a one-room cabin on Lake Tahoe for a little getaway. Roger and I loved being anywhere there were mountains. Our friends Susy and Robert had purchased a second home in the Northern California mountains and invited us to use it whenever they were not there.

We were not shy about taking them up on that offer.

But after a few years, Susy and Robert selfishly moved into that house full-time (I'm writing this with mostly sarcasm), and we were no longer able to use it for the occasional holiday or vacation. We were back to the Airbnb website along with masses of other vacationers.

And that is when we found ourselves in Lake Tahoe, in an Airbnb, dreaming about our own little cabin in the woods.

As we dreamed about owning a tiny mountain retreat, we started to think about how we could Airbnb it. Would we be able to cover the cost

if we rented it out most of the time, and just visited one weekend a month and for a couple of weeks of vacation each year? It seemed like we could make the numbers work.

And then I asked Roger, "What if we could get a place big enough to hold retreats?"

Because you see, I'm a writer. And I love to teach others who love to write. And my crazy, is-it-even-possible dream was to someday host writers' retreats in the mountains.

So we started looking bigger.

(This is the home version of *If You Give a Mouse a Cookie*: We started looking for a one-room vacation retreat and soon were thinking about properties that could sleep a dozen or more people.)

And after a lot of looking and praying (and one day, crying, because a less-fabulous house fell through for us), we got the Red House.

In order to afford the Red House, we had to change a lot in our lives—the main part being that when we were living at home in Silicon Valley, we rented out the Red House as planned, but—and here's the kicker—when we were at the Red House, we rented out our townhouse in Silicon Valley.

The reason we finally made the full-time move to the mountain? An HOA meeting.

Our house in Silicon Valley was a 1,400-square-foot townhouse with neighbors a mere six inches from us. As we traded off living on the mountain and in the city, we had very strict guidelines of who we would rent to (only people who had excellent ratings). However, many of our neighbors in the Bay Area were not familiar with this idea, and they were terrified of short-term renters coming in and staying at our house.

We got wind that some people were going to make a stink about it at the HOA meeting, so Roger decided to attend and represent us. It did not go well. "I didn't say anything," he told me. "If I had, that's when the torches and pitchforks would have come out."

And that is the same day Roger asked me, "What do you think about moving to the mountains full-time?"

If only I'd known that with that one question, our whole lives would change.

Actually, I take that back, because if I'd known all the hard stuff we were going to face, I would have never signed up for this particular adventure. And I would have missed all the good stuff.

At this point, you might be thinking, *I could never be a homesteader!* I got you, girl.

Let's get it straight from the start: Being a country girl was never an aspiration of mine. I was not the girl glued to *Little House on the Prairie* on Monday nights while I was growing up. I have never longed to be outside or described myself as "outdoorsy."

I assumed I never could be a homesteader because

- I didn't grow up in a homestead-y family.

- I thought I would die without Starbucks a minimum of three times a week.

- I spent way more money at HomeGoods than Home Depot.

- I felt like a pioneer if I made dinner five times a week.

- I've never lived in "weather." (In the Bay Area, if it dips below sixty-four degrees, people start layering with scarves and multiple jackets.)

- I basically gave up gardening because I couldn't keep the squirrels out of my four-pot salsa garden.

- Roger has severe environmental allergies.

- I shop in the plus-size section of the store (and you don't see a lot of plus-size people featured in *Mother Earth* magazine).

- I'm highly allergic to mosquitos. Like, one side of my face blows up if I get attacked by a mosquito.

- I hurt my back 25 years ago helping my parents move a box (yes, one box), and I've never fully recovered.

- At our age, Roger and I should be looking at retirement plans, not plans to build a new, expanded chicken house.

- I am decidedly "indoorsy."

- Touching animals besides dogs and cats has always freaked me out.

But I rallied and thought, *Hey, we've lived in the mountains part-time for a year. How different could it be to live there full-time?*

What I didn't realize was the difference between visiting the cabin and living at the cabin.

Visiting the cabin means you can head back to town when you know there is a storm coming and you don't want to get stuck in the mountains. Living at the cabin means you have to dig a snow tunnel to the chickens so you can chip the ice off their water.

That's a big difference.

Living at the cabin means you can't just run to the store for a loaf of bread. It's easier to make one yourself (or let's be honest—just decide bread

isn't that important and crackers with jam is a perfectly acceptable lunch).

Every day up here on the mountain is a day I'm tempted to doubt I have what it takes to make it work. Here, we are surrounded by "mountain people." You know, people who think nothing of spending all day chopping wood or clearing land. While I sometimes debate whether I have the emotional energy to load the dishwasher.

But miracles abound. My certified, citified husband has made the adjustment.

When I first knew him, long before we were married, and he was looking for a house, he told me the one criterion was that it couldn't have a lawn to mow. He hated the idea of mowing a lawn every week.

So sure—let's buy thirty-three wooded acres and call it a day.

But Roger reminds me that there's a difference: Mowing the lawn is a chore, but managing a forest is an adventure.

So here the two of us are, on the adventure of a lifetime.

Because if not now, when?

And if not you, who?

Moving to the mountains? Best not-thought-through decision I've ever made in my life.

I don't know what decision (big or small) you are considering in your own life. Maybe you're looking to retire early and buy an RV and travel across the country. Or maybe you're thinking about changing careers just as other people are deciding that golf is a great way to spend every day of their lives. Maybe this is when you're thinking about starting your new business or moving across the world?

I think we tend to think of these as one big decision that is either right or wrong, good or bad. But truly, they are a thousand little decisions that are either going to change your life or not.

Each decision we made, we asked for God's wisdom and the wisdom of people around us. Some thought we were crazy, but most were excited about the adventure and excited to see where God would lead. (Oh, and my advice? Get more of those excited kind of people in your life.)

❋ OUR FIRST WINTER ❋
(AND ALL THAT WE DIDN'T KNOW)

How much did we not know our first winter? Practically everything. Neither Roger nor I had grown up with a mountain kind of winter. Roger, being from Florida, was much more familiar with hurricanes, and me, being from the California Bay Area, used a thick sweatshirt on rare cold days.

So to say the problems caused by snow were "challenging" doesn't begin to describe it. Between keeping warm, power outages, frozen pipes, a steep, snowy driveway, and more—we were in over our heads.

I didn't know how to build a fire and I needed to learn—*fast*—because, well, we didn't have any other heat sources.

I didn't know anything about chickens except that they taste amazing as a cacciatore.

The list goes on and on.

But if we waited to know all we needed to know to be homesteaders (accidental or otherwise) we would never have made the move. We figured we were two smart adults, and that we could figure it out as we went along. And we did. We do. Sort of.

It seems like there will always be more ways to grow, but isn't that how all great adventures start? And how else can we be lifelong learners if we don't put ourselves into new situations? Not only have our brains expanded exponentially since we moved to the mountain, but our faith has expanded as well. God is our first thought instead of our last resort when a crisis comes up.

When the Power Goes Out

(Because It Will)

*T*here has only been one time we regretted our decision to move to the mountains (so far).

We were on day four of a crazy snowstorm. The heavens had unceremoniously dumped a couple of feet of snow on us all at once. When we bought the house and asked about snow, we were told that the area typically received no more than one or two inches at a time.

Let's just say . . . that has not been our experience.

For six weeks, we'd been calling our propane company to find out when they were going to refill our tank so that we'd be able to run our generator when the power went out. (Because the power? It always goes out.) The propane company kept telling us they were coming that week.

Absolutely.

For sure.

No need to worry.

A week before the big storm was expected to hit, we told them it was becoming an emergency. Every day for a week, they told us they would be there on Wednesday. The storm was predicted to arrive on Thursday.

Of course, they never came.

We went into a giant storm with less than 15 percent of our tank filled. On Thursday we lost power. For several days we kept flipping the generator on and off, using it about three hours a day just to turn on our

computers, run a heater upstairs for a bit, cook a meal, and pump our well.

On the fifth day, the generator just stopped. It hadn't run out of fuel (that would happen in another couple of days); it just plain old died.

We were stuck in our house, snowed in, with no power, no backup generator, and no water. (Our well requires either electricity or the generator to run.) When we heard the engine fail, we just looked at each other and said, "What are we going to do?" (Okay, there may have been more colorful language than that. Because to be honest, we were scared.)

For a couple of days, we melted snow so we could have water to bathe in and to flush toilets with (we always keep some bottled water on hand for cooking and drinking, just in case). We heated up food on the wood-burning stove, slept under piles of blankets next to the fireplace, and tried to convince our dog, Moose, to go to the bathroom in the snow. (She wasn't having any of it.)

Roger, my software engineer turned mountain man, started digging out our quarter-mile, uphill, driveway so we could drive out. After hours and hours of digging and our truck almost making it to the road, we got stuck at the very top of the driveway.

And that's when our neighbors Paul and Julie—volunteer firefighters and all-around legit homesteading superheroes—showed up with their Bobcat, tied a rope to our bumper, and pulled us up the mountain and onto the main road so we could get down to "the flatland" and the safety of my mom's house (with a quick stop for a steaming hot cup of Starbucks, of course).

There is no faster learning curve in homesteading than being trapped in your house with the power out.

We were as prepared as we could possibly have been, but being prepared doesn't always mean you won't get stuck in a situation you don't want to be in. (And being trapped inside in a snowstorm always seems super romantic until you realize you need to melt snow in giant Home Depot buckets in order to flush toilets.)

And even with all your advance planning and prepping, when things

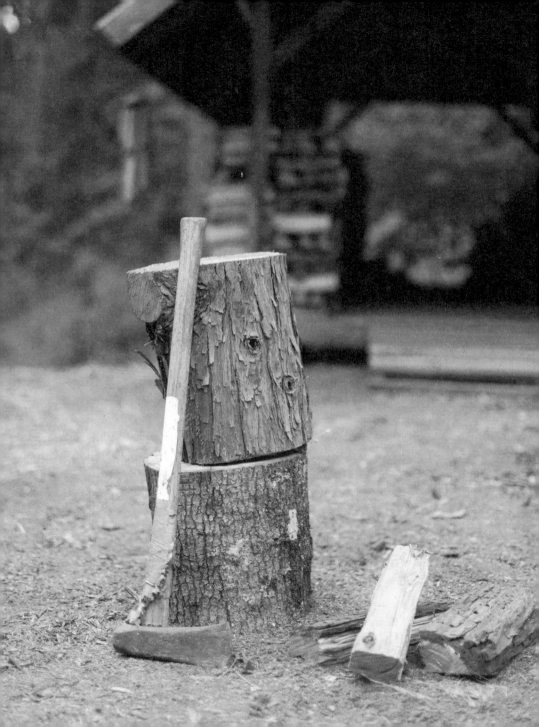

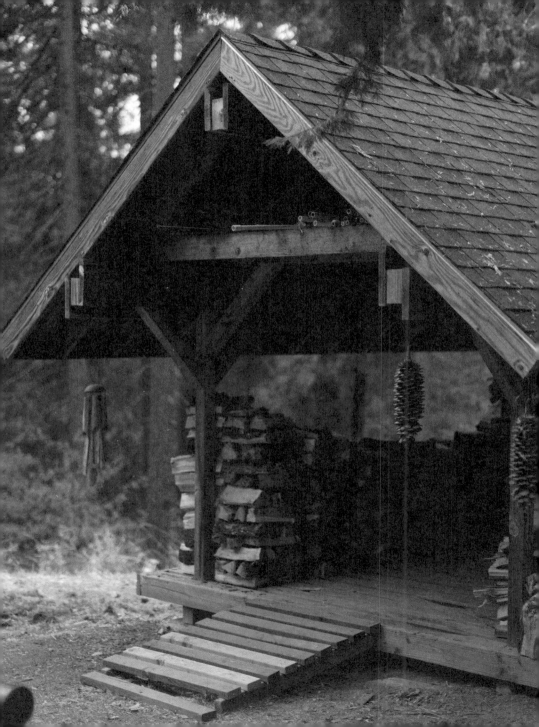

get really bad, you may still find yourself sledding chickens out to safety on snowboards (like we did).

How to Survive a Power Outage the Accidental Homesteader Way

There are usually two reasons the power goes out up here: It's too hot or it's too cold.

When it's too hot, our power company will often shut off the power because of extreme fire danger. Fallen trees on live power lines have caused some of the biggest wildfires on the West Coast.

When it's too cold, we are likely to lose power because of snow and wind bringing down trees and severing power lines. That is exactly what happened to us our first winter when the snow load became too much for the trees in our area. Our town was without power for over ten days. We also are in the most remote part of the county, so our little mountain town is always the last place to have power restored.

Having a backup generator became our first priority when we started to live here full-time. But you want to use the propane in that generator sparingly for a number of reasons:

1. You don't know how long the power will be out.

2. You pay a lot for propane. If we ran our propane generator for a full day, it would cost us over $100.

3. You are at the mercy of the weather and the propane company as to when your tank will be refilled.

Before the Power Outage

Thankfully, we often receive warnings ahead of time about power outages. When they can, the power company will let us know that we will be without power for a while. But whether you know about it in advance or it happens suddenly, there are many things you can do to prepare for when the power goes out.

1. Prep your kits. We have two easy-to-access places where we keep our power outage supplies:

- A designated drawer in our kitchen. This is where we keep what we'll need right away to navigate the darkness, like flashlights, headlamps, multi-outlet charging port, charging cords, and solar lanterns (charged).

- A designated tub in our garage, which holds solar batteries, candles, lighters, more lanterns, a battery-operated DVD player with built-in screen, a NOAA weather radio, and a plastic tub for washing dishes.

2. Assess your resources of food, fuel, communication, and entertainment.

Our motto when it comes to preparing food for power outages is fill up in fall, stop buying in spring.

We've never been trapped in our house during a warm power outage. We can always still get to the store. What you don't want is to have a ton of food in your freezer and fridge go bad during a warm power outage. I've chipped refrozen rotted food out of a deep freeze. Trust me—it's not how you want to spend an afternoon.

But in the winter, you want to have a lot of food on hand—at least enough for two weeks. Most of us have an outdoor grill of one kind or another. In a power outage (especially if you don't have a generator), your grill will be the best and easiest way for you to heat food up. Make sure you have plenty of fuel: gas, charcoal, or wood pellets.

Speaking of fuel, you'll also want to have plenty of firewood stacked and ready to go. We have a woodshed that Roger spends all spring, summer, and fall filling with chopped wood. If you don't have a shed, grab a couple of pallets and store the wood off the ground, and be sure to cover it with a tarp when rain or snow is expected. (There's nothing worse than wet wood when you're trying to start a fire.)

Get a pair of walkie-talkies and always keep them charged. (They now have walkie-talkies that charge with a USB cable—much more reliable than charging them on a stand.)

Download those TV shows and movies on your rechargeable tablet that you've been meaning to get to but just can't find the time to watch. (Because you're a homesteader.) But one good thing about a power outage as a homesteader: You will have the time to watch all those shows everyone has been talking about!

During the Power Outage

Before you flick the generator on:

1. Have the coffeepot ready to go.

 I am much better in an emergency (or even in an inconvenience) if there is coffee readily available. So when we flick the generator on, I either have the coffeepot set and ready to go, or if I need to grind beans, I have them ready to grind.

 Make a pot of coffee and then immediately put it in a thermos so it will stay warm as long as possible. You will be especially grateful for this if your power is out due to snow pulling down a powerline.

2. ABC: Always Be Charging.

 I'm sitting here writing this chapter of the book while the power is out, but I can keep working on it for the next couple of hours because I always have my computer charging. Don't think of me as disciplined. Think of me as someone who has been on a deadline with a 5 percent battery. Pain is a great teacher.

3. Preserve your food.

 Open your fridge and your freezer as little as possible. You want to keep all that good, cold air in there as long as you can. If your power is out due to a snowstorm, pack your fridge and freezer with plastic food-storage containers filled with snow.

4. Plan ahead for meals.

 When I'm cooking on the grill, I like to think through my meals for the day. If I'm sautéing veggies for an egg scramble in the

morning, I will go ahead and double the veggies so I can eat them with meat at dinner or throw them on a salad or sandwich for lunch. While you cook your pot of oatmeal and apricots for breakfast, you can also grill chicken breasts for your lunch and boil pasta for dinner. That way, you are preserving your fuel source in case you are out of power for longer than expected.

5. Be creative and enjoy your meals.

Make sure that even if you are using up some of your frozen food or are having to go deep into your canned pantry, you are not being shy about using your seasoning stockpile. Your food will always taste better with seasoning. There is this weird idea that as long as we are hungry, we can eat anything. But it's easy to get tired of food and have a hard time digesting the same thing over and over again. Use spices and seasonings to keep your meals as interesting and delicious as possible.

Meals to Make When the Power Goes Out

In a power outage, it is more important than ever to follow the adage "fresh first."

1. Use fresh meats, vegetables, fruits, breads, and dairy first.

2. Use frozen foods next. Until you are ready to eat your frozen food, keep it tightly packed in your freezer and don't open the door in order to keep things as solid as possible.

3. Finally, use your shelf-stable items. The goal is to make sure your food will last as long as possible.

Here is a sample menu to use up your food before it spoils.

Day 1:

On the first day, you are going to be spending a lot of time getting your lights set up, your tech items charging, and if it's cold, shoveling

snow. Make meals that are simple, using up your ingredients that will go bad first.

Breakfast: Yogurt and granola with fresh fruit

Lunch: Salad with fresh chicken

Dinner: Leftovers

Day 2:

You should have a little more time today to think about food. Keep using things from your fridge that will go bad first, paying attention to expiration dates.

Breakfast: Eggs and breakfast meats (bacon, sausage, etc.)

Lunch: Lunch meat sandwiches, fruit

Dinner: Quesadillas and salad

Day 3:

Breakfast: Cereal with milk and fresh fruit

Lunch: Grilled cheese sandwiches with lunch meat, grilled vegetables

Dinner: Vegetable soup made with any veggies in the fridge cooked in vegetable juice or chicken broth (feel free to add leftover chicken)

Day 4:

This is when you'll want to start using anything you have in the freezer.

Breakfast: Sausage and frozen waffles heated up in a pan. Make a syrup of frozen berries.

Lunch: This will be the last day you'll want to eat some of the stuff in your fridge, so make this lunch count!

Dinner: Grill some hamburgers (whether the meat is fresh or frozen). Make a side salad, and if you have an air fryer, it's time to bust that out with some frozen French fries!

If you're flicking your power off for most of the day, take every plastic tub or storage container you have and fill them up with snow to keep your fridge cold.

Making Your Power Last

After an area-wide power outage, your gas provider probably isn't standing on your doorstep waiting to fill your tank back up. You are completely at their mercy as to when your tank will be refilled, so you need to make what you have left last as long as possible.

If you will be having fits and starts of power, here is what you'll want to do when the power actually comes back on.

Before you flick on the generator:

1. Plug in everything that will need to be powered up, like phones, tablets, laptops, solar lights, rechargeable batteries, and a NOAA radio.

2. Prep any food you'll want to cook or microwave, making sure it's all ready to go. (Don't waste valuable electricity-on time chopping and prepping.)

3. Know where to hang the solar lights: The kitchen and bathrooms are the most critical places, along with a roaming light for walking. (Using a lantern to guide the way through your house will make you feel very Velma from *Scooby Doo*.)

And once the generator is running, here is your list of the most important things you'll need to do:

1. Use the bathroom. (When no power means no plumbing, you'll really enjoy the luxury of that flush.)

2. Fill up a wash tub with hot water for washing dishes.

3. Take that shower. (Make it short but enjoy it thoroughly.)

4. If it's cold, put a heating pad in your bed or turn on your electric blanket to warm it up.

5. Make sure your mail updates on your computer.

6. Download new shows to watch on your tablet.

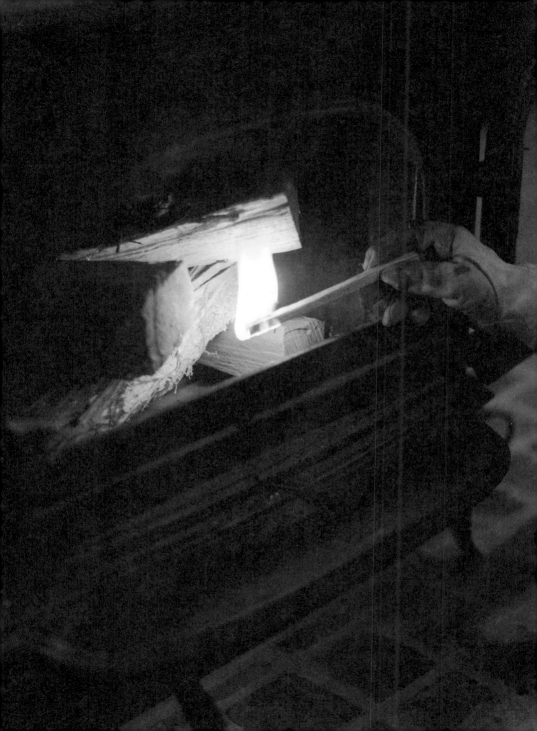

Prepare Before the Need Arises

As with so many aspects of homesteading, once there is a problem, it's often too late to do much about it. We didn't know what we didn't know our first year here on the mountain. We thought our tools would magically work, it would only snow a couple of inches at a time, and we could just run to the store if we needed anything.

None of those turned out the be the case.

That's why we:

- have the small motor guy come out in the fall to tune up our ATV, chain saws, lawn mowers, log splitter, snow blower, power washer, auger, tiller;

- do all the outdoor chores before even a small snow, like prep the chicken coop, cover the plants, and bring in the firewood; and

- always keep a couple of weeks of easily accessible food on hand, as well as some long-term emergency food—and with all those cans, make sure you have a can opener that doesn't require electricity in order to operate it! (See page 170 for emergency food supply suggestions.)

No matter where you live, doing the little things to prepare in advance will make the challenging parts of life better and easier.

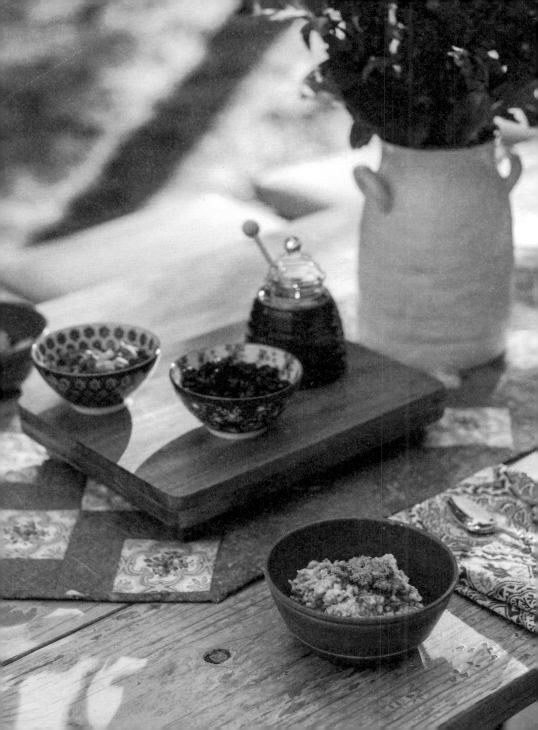

Take-Care-of-Your-Future-Self Oatmeal

I am addicted to oatmeal. I know—is there anything on the planet more boring to be addicted to than cream mush? My edginess level has to be at a three...

But there is nothing more comforting to me than a warm, cinnamon-y bowl of oats with fruit and granola. I hear that there are people who love savory oatmeal with meat and cheese and veggies, and the only word that comes to mind when I hear about these people is "psychopath."

But I'm not here to judge.

When we don't have guests at the house, this one recipe will feed me for a full week, so I make a batch of it on Sunday night and wake up to hot oatmeal on Monday morning. That's the day I most need my breakfast to be waiting for me—amazing, hot, and ready to go. And if I decide I don't want oatmeal on one or two mornings, I can heat it up and serve it to the chickens for an extra treat. They love theirs with a mix-in of mealworms. (I do not suggest that particular topping for the humans in your home.)

Ingredients

- 1.5 cups steel-cut oats
- 4 cups water
- 2 cups milk, any kind you like (I use nonfat)
- 2 large, ripe bananas, mashed (frozen is okay, but fresh bananas taste better)
- 1 cup dried apricots, chopped
- 2 tsp. pure vanilla extract
- ½ tsp. ground cinnamon
- ½ tsp. ground nutmeg
- ½ tsp. kosher salt

I also like to put a little sweetener in the oatmeal. You can either add it to the oatmeal while it cooks, or as a topping when you are ready to eat. Dealer's choice: brown sugar, white sugar, honey, or agave nectar.

Toppings (use any combination you have on hand):

- blueberries
- strawberries (quartered)
- raspberries
- blackberries
- peaches (canned with the syrup drained, or fresh and ripe when in season)
- granola
- shredded coconut
- sliced almonds
- chopped pecans
- Greek yogurt

Directions

Place all the ingredients except the toppings in the bottom of a 4- to 6-quart slow cooker, then stir to combine. Cover and cook on low for 8 hours. Remove the cover and stir. Taste and see if you need to add anything else, like more vanilla or cinnamon.

6 Servings

I like to keep oatmeal in the fridge in a big tub to reheat for up to a week. I reheat individual servings in the microwave for 2 minutes and 30 seconds.

My husband rarely eats oatmeal but will for sure grab some after he's been smelling it all Monday morning.

Oatmeal is also an excellent breakfast for when we have a bunch of guests here at the Red House. For each writers' retreat, our first breakfast will always be an oatmeal and yogurt bar. It's easy to set up ahead of time, and almost everyone, no matter what their diets are, can eat some variation of the oatmeal and toppings. (If you are feeding someone with a severe gluten allergy, be sure to get oatmeal that is certified gluten-free.)

Here are the elements of a great oatmeal and yogurt bar:

1. A bunch of serving bowls
2. A slow cooker filled with unsweetened oatmeal (I always give it a good stir before serving, then put a soup ladle in the cooker so people can serve themselves)
3. A bowl of plain yogurt
4. Sweeteners, as listed in the recipe
5. Toppings (in addition to the healthy toppings above, sometimes I like to throw in some chocolate chips to add some zing for guests)

My Favorite Topping: Stewed Apples and Cinnamon

I'm sure there are official recipes to make stewed apples, but what I've come up with is easy and delicious, so I'll stick with it.

Ingredients

2 T. butter

2 apples, peeled and chopped (we love Honeycrisp or Granny Smith, but any apple will do)

1 cup water

2 T. cinnamon

Directions

Heat the butter in a large skillet and add the chopped apples. Sauté the apples for about 5 minutes, then add water and cinnamon and let it cook for about 7 minutes or until the water is evaporated.

I serve this over my oatmeal, and it is *amazing*.

Kitchen Tool Tip

Since we live in apple country and can pick apples for free on abandoned orchards, we broke down and bought an apple peeler/corer/slicer.

Best apple money we've ever spent.

I can get through half a dozen apples in about five minutes. And peeled, cored, and sliced apples are the best when it comes to putting them in the slow cooker for apple-cinnamon oatmeal. Enjoy.

Take Care of Your Future Self

Always look for ways today to take care of tomorrow's you.

If you are homesteading (or even pseudo-homesteading), you have not chosen the easy route. It's a rewarding route, but it isn't exactly the convenient route. That's why I encourage you to create every single advantage you can to make life easier. One of those things is to think about what you could do in advance to make your tomorrow a little bit easier.

Monday is one of our busiest mornings of the week, so anything we can do ahead of time to take the pressure off at seven a.m. Monday is in the win column.

Here's our Sunday night routine:

- Set up the coffee.
- Prepare the oatmeal and start the slow cooker. (Make enough for the entire week.)
- Clean any fruit we want to eat in the morning.
- Pull out some meat to defrost for Monday night dinner.
- Do the dishes.

My Monday self is so, so grateful that my Sunday-night self took such good care of me.

On the homestead, you have no idea what tomorrow will bring. By setting up as much as you can beforehand and being ready to go, you will make your life a little bit better every day.

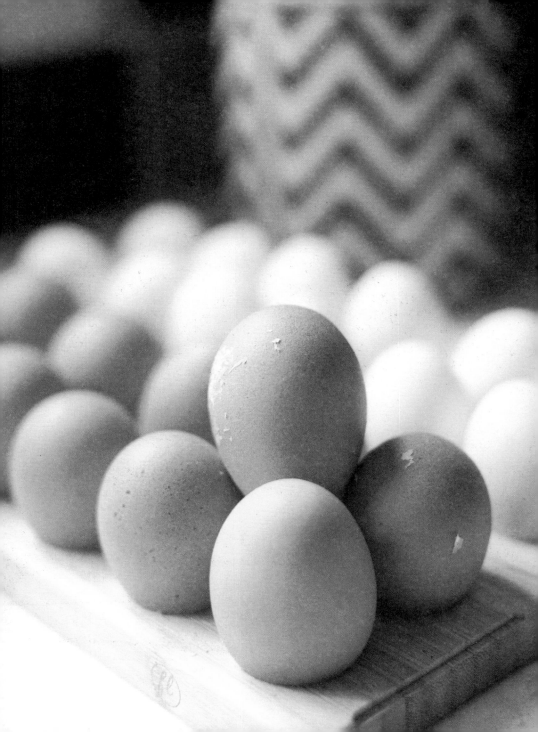

Making Your Homestead a Home

I told my publisher I wanted to write a book about our journey of becoming accidental homesteaders. And then my publisher told me they wanted to turn this into a book filled with photographs of our life and our home.

At first, I loved the idea of sharing our messy, in-process life with other people who are also messy and in process.

But then I started to feel all sorts of pressure (from myself) to make sure the house was "done." As in, cute-as-a-baby-chick's-first-time-in-the-grass adorable.

So I went on a list-making spree. I decided my five-year plan needed to be accomplished in the next seven months so I could show everyone how cute our house is.

And let's be clear—our house is cute. I love our house.

But is it perfect? Is it how I had always envisioned it? Not so much.

So do I give you the real picture of how it looks now, or do I give you the picture of how I want it to look in five years?

Everything inside me is chanting, "Five years! Five years!"

When we first bought the house, we were using it as an Airbnb, so I had to get the house cute—fast.

I bought all the throw pillows, throw blankets (pretty much anything you could throw), and knickknacks to make it look like a place people would be dying to stay when they came to wine country. And we rented

this house like crazy. (The décor must have worked, because we have never received anything less than a five-star review.)

I'll admit, I went a little crazy decorating the space with pictures and tchotchkes—anything to give it more of the "mountain feel" Roger and I had dreamed of as we planned our cabin in the woods.

But we had to figure out our own mountain vibe. Less "bears in the woods" and more "boho on the mountain."

And we needed to understand that this house couldn't help but have a mountain feel because it is in the mountains. (In other words, I didn't need to try so hard.)

When we made the huge leap to move here full-time, we slowly started to turn the house from a five-star Airbnb to Roger and Kathi's actual home.

And I do mean slowly.

We are officially part of the slow decorating movement. We don't settle for "it will do." We wait for "that's exactly what I want."

That is exactly the same philosophy we have with most projects here on the mountain. Because there is never a column in the life of a home-steader that gets marked as "done." There is always one project starting, about eighteen somewhere in the middle, and if you're really lucky, one on the edge of done-ish. (Oh, and about twenty-three in the dreaming and planning stages.)

But the house? The yard? Nothing is ever "done." Everything is always in process.

This house.

This property.

Us.

Because it's amazing how many obstacles to "done" come up.

Parts of this book are going to show you some of the things that are done. But a lot of this book features things that are in process. I'm guessing your home is the same.

It's kind of like what we grow around here. Something is always being planted, and something is always being ushered into maturity so that it will live. Something is always dying, and something is always being torn

down. And sometimes the land is just resting.

I love an in-process home, an in-process piece of land, and an in-process person. The only houses that aren't constantly in process are the ones on HGTV.

If your house is a mix between "waiting for the tile guy to get back to you" and "early drop cloth," I've got you.

I have rooms I love.

I have rooms I live with.

But every room is a work in process.

Real people and real animals live at our house. Notice that in so many decorating magazines, you'll see a cat lounging on the front porch, but I have yet to see a litter box in any home layout (just sayin'). Not only do we cook delicious meals, but we also create a sink full of dishes and a fridge full of leftovers. (And let me tell you, I love leftovers. They are a gift from yesterday Kathi saying, "Here, let me feed you.") Occasionally, you'll see garbage cans overflowing because we are busy repairing the chicken fence. It's real around here.

There is another word for *perfect* when it comes to homes—*boring*. Our lives and our house are anything but boring. Some of our furniture is cheap and Swedish. Some of it is hand-me-downs from hand-me-downs. Some of it is actually falling apart and we have to be very strategic about how we keep it from falling apart. (I love me some Gorilla Glue.)

Perfect is not the goal. Loved and lovely is the goal.

I've found that as much as I love to see our outdoors growing with chickens and gardens and all the things that make a homestead, if I want to make sure we're also creating a home, I need to pay attention to the indoors. As we harden the outside of our home, I also want to create a soft place to land at the end of a day of hard work. I want this to be the most comforting, safest sanctuary for me, my family, and anyone else who visits our home.

It's okay for your home to be in progress, both on the outside and the inside. That's how you create the home you've always wanted to live in: one task at a time, one project at a time, one day at a time.

The Tile Project

One day I was scrolling through Pinterest and came across Claude Monet's kitchen in his home in Giverny, France. It was an explosion of blue and white, and I couldn't stop looking at it. I started to do some research about the type of tile on the walls. They are called Delft tiles and have a rich heritage starting in China and making their way to the tiny town of Delft, Holland, then eventually to Monet's part of France. In the seventeenth century, Delft tiles were installed in almost every house in the Netherlands that had the means. Delft tiles work well in damp and smoky rooms—like kitchens or rooms with fireplaces—because they are easy to care for.

Beautiful and ease of care? Sign me up, Claude.

As I learned more of their history and saw more and more pictures of other kitchens that had Delft tiles, I was hooked. I wanted my own kitchen covered in Delft.

I contacted an artist who specializes in Delft tilework, and I let her know my grand scheme. I wanted her to hand design tiles that told the story of the Red House. Things like . . .

- pictures of all the pets we've had here
- a picture of the bell we ring every time a writer hits 500 words while they are writing here at the house

- a coffee cup

- dragonflies and butterflies and even snails and slugs

- a picture of a church, since so much of our life and marriage has been centered around church

- pictures of all the forest animals we've encountered here

She sent me almost forty hand-designed tiles, and then I ordered some plain blue and white tiles to fill out our space. When I finally laid out all the tiles, after a year of going back and forth with this designer, Roger and I realized we didn't want so many plain blue and white tiles. So we ordered a bunch more tiles from the artist.

If I'd known it was going to take almost two years to complete this project, I doubt I would have ever started. But I'm so glad we did, because I've learned so much along the way.

My best pieces of advice for decorating and home projects:

1. Your best household resources are time and patience.

2. On big projects, keep kicking the can down the road. This is one of those old-timey expressions that really means doing a little every day. Not only does this get your project closer to the finish line, but it helps you see ahead of time problems that are going to come up. You may discover you don't have all the items you need, you don't have all the knowledge you need, or you don't have all the money you need.

3. Live in the space. Be slow to make big decisions.

4. Don't be willing to buy anything you are not willing to return if it doesn't work in the space.

5. Assume that every project will have more roadblocks than you know, more changes than you can imagine, will take longer than you planned, and will cost more than you had hoped. And it will be okay. Creating the home that you actually want to do life in is worth the effort.

Useful, Beautiful

Several years ago on a trip to New York, our family went to the Metropolitan Museum of Art. After exploring the museum, I was perusing the gift shop, where they had books, bags, umbrellas, and cards all with the prints of William Morris on them. William Morris (1834–1896) was a textile designer and the leader of the British Arts and Crafts movement of the second half of the nineteenth century. At the museum, I found a notebook with one of his designs on it along with a quote of his: "Have nothing in your house that you do not know to be useful or believe to be beautiful."

That is the exact philosophy I've tried to adopt up here on the mountain. We need a lot of stuff to run this place. But can we make them beautiful and useful.

We also try to limit the number of knickknacks we display and things we hang on walls to keep lines clean and spaces uncluttered.

As I consider items to bring into my house, I ask myself, "Is this useful and beautiful?" That simple question has made me put back more than a few chicken knickknacks at HomeGoods.

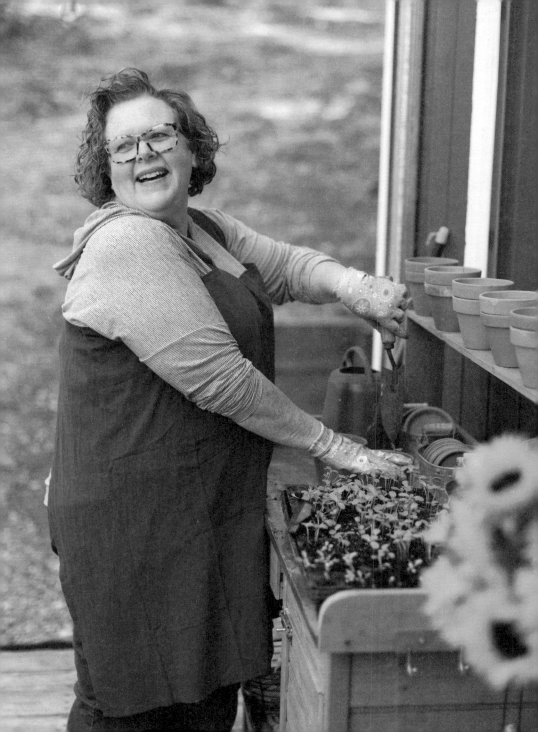

Seed Starting

There is no human more full of hope than the homesteader planting seeds in February.

The sky is bleak, the weather dreary, and the idea of spring seems ridiculous on the face of it.

But plant the seeds in February you must. Then you'll be ready to greet spring with plants that can hold up here on the mountain, protected by the greenhouse, in May. (In April, we've learned, Mother Nature still has one plant-killing frost up her sleeve.)

I like to imagine the tomato salads we will feast on, the pesto we will slather on our bread, and the berries that will sweeten my oatmeal in the coming months. This inspires me to just trust and move forward in February with all things gardening on days when the sun sets at a quarter past five in the afternoon.

I'm going to encourage you to do something completely opposite of where your homesteading heart wants to take you: Read the directions on the back of the seed packet. You may think real homesteaders are too cool to read the directions, but remember, we're accidental homesteaders around here, and we need all the help we can get.

I know, I know. Your pioneering heart screams to your brain, "You don't need instructions! Your foremothers knew how to do this by instinct. This will be the Hunger Games of food production. Just spread the seeds around and whatever takes, takes. There you go, little San Marzano tomatoes! And may the odds be ever in your favor!"

A couple of problems with this approach:

1. Your foremothers had *their* foremothers to teach them how to plant seeds. They didn't do it by instinct—people who knew what they were doing taught them how to plant. And those foremothers? They got jobs at the seed companies writing instructions on the backs of the seed packets. They are sharing their hard-won wisdom. Listen to them.

2. This approach can lead to you subsisting off a diet of eggplant abundance and a few scraggly tomatoes. I want better for you.

3. After a few years of reading seed envelopes, you can become that woman who instinctively knows how and when to plant seeds. You'll impress your friends with your deep knowledge of planting techniques, soil alkaline readings, and watering habits. But you have to walk before you can fly.

So do all your future plants a favor. Follow what is written on the back of that seed packet.

Here's what you will need to get your seeds started:

- a garden propagator set with seed starter tray, dome, and base (15 x 9-inch)
- a chopstick
- seed starter potting mix
- seed packets
- plant tags (or popsicle sticks)
- plant heating mat

My favorite way to start seeds is in a seed tray with dozens of little cups with holes in the bottom, a tray underneath, and a clear plastic dome over the top to keep the moisture in and the cold out. With the bottom plastic tray, you can water your seedlings from the roots so the plants get exactly what they need.

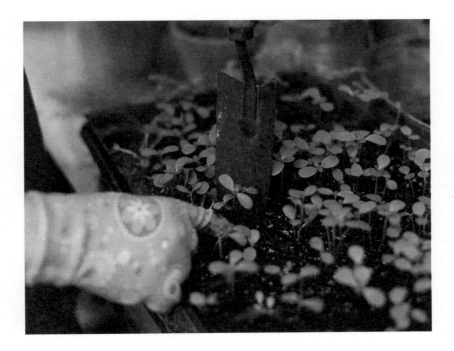

Plant the Right Seeds

I like to plant seeds that need similar conditions to thrive in the same trays. When thinking about what to plant together, consider the seasons. Some of my favorite summer flowers, fruits, and vegetables grow great with a heating mat, and they can all be planted together:

sunflowers	basil	peppers
salvias	corn	rosemary
cosmos	eggplant	tomatoes

All of these "summer crops" do better with some additional heat to help them along.

Fill up those cups with seed starter potting mix, then use a chopstick or skewer to poke a hole in the dirt in each cup to the depth that is

recommended on the seed packet. Put the seeds in the hole and fill in the hole with potting mix.

Water the Seeds

Pour water into the base trays and place the domes on those trays.

Don't do what I've done for the past few years, which is plant all the seeds and then stick the trays in an unused room under a heat lamp so they will be out of the way. No—those seed trays need to be front and center in your life so you'll remember to water them. They should not be ignored. Just decide they are the centerpiece on your dining room table for the next couple of months. Or perhaps put them in your living room right next to the remote control. Why? Because there are exactly sixty-seven needs that are more pressing than going all the way into another room to water those baby seeds, and you will always think they'll be fine for one more day. You can easily "one more day" yourself into some shriveled up little baby plants you have murdered because the dishes needed to be done. You do not want to be responsible for all those lives on your hands. (Hint: The dishes always need to be done.)

Know Your Gardening Zone

We are in gardening zone 8b. Having this information lets me know what plants will thrive in our mountain environment and what plants will fail miserably. It also tells me when I can expect the first and last frost of the year. I don't want to start those little seeds only to watch them freeze because I planted them outside too early.

You can use plantmaps.com to look up your gardening zone. I was fascinated to learn that we are part of the Köppen-Geiger climate zone Csa—Hot-summer Mediterranean climate, which is why grapes that do well in Mediterranean climates (like Tuscany and most other Central-Southern Italian, Greek, Marsala, Sicily, and Israeli regions) do well in all the vineyards surrounding our mountain. We have forty local wineries within a half hour of our house, but no grocery stores.

You Don't Have to Do Everything the Hard Way

I love flexing on others by saying, "Yep, I grew that tomato from a seed." There is hardly any feeling more satisfying than seeing a seed go from something in a package to a Caprese salad.

And at the same time, there is nothing wrong with getting a few starter plants to get you going if you have a little bit of money and are running low on patience or if you are getting started later than you thought. I've been there. Sometimes you just need to replace that basil plant because yours is getting woody and, well, it's just time. It is always preferable to buy a starter plant and take cuttings instead of buying those tiny packets of plastic packaged herbs in the produce section of the grocery store. Starter plants cost the same, but they'll yield herbs for months or years to come. There are a lot of new skills to master as wannabe homesteaders. It's okay to take the cheats where and when you can.

As you grow in your gardening knowledge (I would consider myself a well-practiced total amateur), it's fun to try things that are beyond your tried and trues. This is our first year growing grapes (for snacking, not crushing). And though we live near Lake Tahoe, this kind of gambling—the kind that involves fertilizer and seed mats—is our favorite way to potentially throw away money. At least we are learning something in the process.

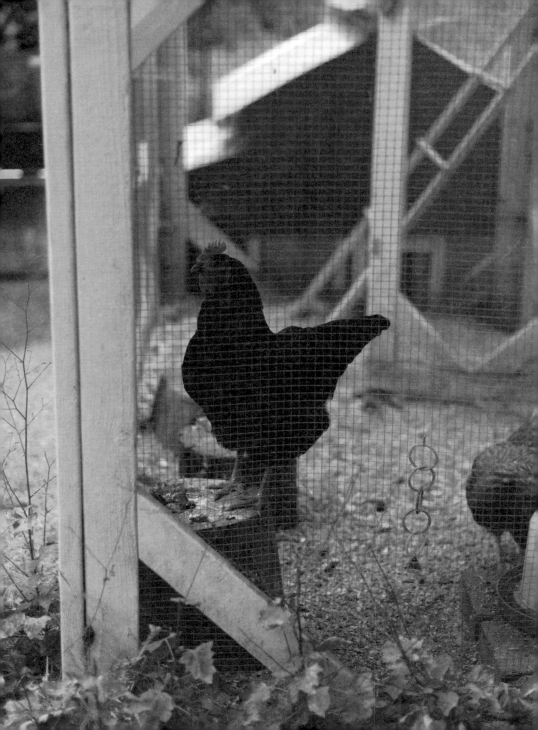

The Accidental Homesteader's Approach to Animals

Our number one consideration when it comes to the ladies (that's what we call our mini flock of chickens) is their safety. I had several friends tell me that if you want to have chickens, you have to get used to seeing dead chickens. (Some of my friends can be real downers.)

The thought of losing a chicken terrified me. I remember what it took to get over the death of our puggle, Jake. Who am I kidding? I'm still not fully over it. I grieved more for Jake than I did for certain dead relatives.

I could not imagine losing another pet. And just to be clear—these are not meat birds. They are for eggs, but also for cuteness.

But here is what I've discovered since raising chickens. My heart has a lot of different compartments. There is my love-for-God compartment, my undying-love-for-Roger compartment, my kid compartment, and my compartment for Moose (the dog) and Ashley (the cat). In another compartment are my chickens. It is a compartment, but my love for them is different from my love for people or our dog and cat. The chickens can be very sweet (actually, their sweetness pretty much only exhibits itself when there is the hope of "snackies"), but for me, and for many people I know who raise chickens, you must hold your love for chickens more loosely because there are so many things that can happen to livestock. Or "pet-stock," as we like to call it, as that's the combination of what our chickens are—pets and livestock.

While my chickens are in a different love compartment, it is a love compartment, and I wanted the chickens to survive their first night out in their coop.

After moving the tiny baby chicks from the half bath upstairs to the patio bedroom downstairs, we were approaching the time to think about moving them outdoors and into their coop.

But when it came to determining when the girls' first night out would be, I was a little more than nervous. Roger kept saying, "They are supposed to live outdoors at six weeks, right?" And I said, "No! Six to eight weeks! Stop pushing my babies out the door!" It felt like he was trying to send my toddlers off to military boot camp.

But Roger knows how much I want to protect these girls, so he proceeded to build the Fort Knox of chicken coops.

We got a kit that advertised it would take an experienced handyman two hours to put together and a novice six hours.

It took Roger twelve hours.

I blame wonky directions and an optimistic kit designer, not my very capable husband. It was advertised as a Michael's project and turned out to be a Home Depot Pro project.

After the coop, he made the chicken run from scratch, which had to be reinforced over and over for the ladies to be safe in the mountains. After all his building and reinforcements? Let me tell you, the Birdman of Alcatraz had an easier time getting off the Rock than a predator would have getting into our coop.

Finally, it was time to put the girls in their new home for their first overnight. But before we did, we ran a test. We set up a trap cam and baited the coop and run with a chicken and some sliced pork to attract wildlife. (Don't worry. The chicken's name was Costco Rotisserie.) And then we waited.

The first night, fox and deer made an appearance on that trap cam.

The second night, some kind of wild cat and the fox again.

Yes, we had a repeat visitor, but the good news is that it didn't even

look like the fox was attempting to get into the chicken coop. We felt reasonably safe that the coop could keep out the local wildlife since foxes are smart and they weren't even trying to get to Costco.

Finally, the night of the big move arrived, and we placed the girls in their coop and went to bed, knowing we'd be up at least a couple of times in the night to check on them. Ten p.m. check? All's well.

Now, let me just state for the record that Roger is much better in these "middle of the night emergency scenarios" than I am. When I sleep, I tend to sleep as though I'm in a medically induced coma. I was once at a business retreat at a hotel on the beach in Santa Cruz. I met my coworkers for breakfast after the first night there, and they all asked me where I'd been that night. I had no idea what they were talking about. Turns out there had been a small fire at the hotel in the middle of the night, so the staff had sounded the alarm to evacuate all the guests. Except me. I slept through the hotel's fire alarm and the twenty phone calls from my panicked coworkers.

At twelve thirty a.m. on the chickens' first overnight in the coop, Moose bolted out of bed and barked in a way I've never heard her bark before. Not a "this is my house, you must throw a ball to me before I decide you are okay" bark, but a "I will defend this house and my people at all costs, even if it means my life" kind of bark (which was not at all diminished by the fact that she weighs less than nine pounds).

Roger jumped out of bed too and headed to our front bedroom window, only to see a giant California black bear at the front of the house.

We heard a loud bang, and then Roger watched as the bear galumphed away, defeated, and headed back into the forest.

Turns out, the bear wasn't interested in our baby chickens. This particular bear was interested in the pantry that we keep in the garage with Roger's nacho cheese Doritos and my mint chip Yasso bars. And we have the bear claw marks on our garage door to remind us of the visit.

An Ode to Soup

Before we became homesteaders, I always enjoyed an occasional bowl of chicken noodle or butternut squash soup. Now that we live full-time up here on the mountain, soup is so much more than a bunch of ingredients thrown into a pot. Soup is a way of life.

I never knew all the benefits of this most basic of food groups. But the more I make soup, the more I realize that soup not only feeds our tummies but also gives us so, so much more.

Soup forgives. Soup is the most forgiving of all the food categories. I have never once in my life thrown out a pot of soup. There is always a spice to be added, a grain to absorb some of the liquid, another veggie to add some texture. No soup is ever beyond redemption.

Soup redeems. Have a motley crew of leftovers in your fridge? Maybe there is extra chicken from last night's dinner, along with some potatoes that need to be used up this week before they start growing eyes. Remember all those veggies you bought last week with the best of intentions but without a plan? All of those orphans of the weeknight dinner plan are now the perfect, glorious ingredients for a pot of delicious, healthy, hearty soup.

Soup feeds. A pot of soup is meant to be shared, whether that is with your roommate, the love of your life, your parents, your kids, or the neighbor next door. Soup is never meant to be hoarded.

Soup stretches. Find out you have more people coming for Sunday supper than originally planned? No worries. Soup is here to save the day. Many a soup has been stretched with some leftover chicken from the freezer, additional sautéed veggies, and extra chicken stock.

Soup is patient. Want to take it easy on Sunday? Soup is in no rush. Make it on Saturday, or even Friday, and it will keep and be ready with minimum fuss.

Soup is flexible. No one should ever say, "I can't make soup. I don't have the ingredients." A soup recipe is a mere suggestion based on ingredients one person found in the larder, cooked together, and declared delicious. When it comes to soup, a recipe is just an idea for you to improve upon.

Soup is surprising. All soup is good. And sometimes, soup is great. Just like all artistic endeavors, every once in a while you'll hit just the right balance. With soup, that ideal balance is one of salt, fat, acid, and yum that makes an especially delicious concoction—something that needs to be remembered and written down. This is the best thing about soup: the adventure.

The more I make my weekly soup, the more I realize that soup sets the rhythm for my entire week and helps with my weekly meal-planning.

Sunday: Sabbath Soup Day

This is the day we take our Sabbath. No unnecessary work is completed on Saturday night and all day Sunday. We worship, we rest, we hang out with friends and family, and we eat great food, including the soup I've been planning all week for Sunday's lunch.

For dinner, I love a good DIY meal. This might be a charcuterie board, a sandwich spread, or a baked potato or salad bar. Anything where I can just set stuff out and let people build their own. (And let's be honest, if we have guests, I'm happy to put things in pretty dishes, but if it's only Roger and me, I'll just line the packages up on the counter.)

Monday: Eat Leftovers

This is our crazy-busy workday. I plan for us to eat only leftovers on this day. That usually means leftover soup for lunch, plus something else left over from the weekend for dinner.

Tuesday: Prep the Fridge, Plan Meals, and Make the List

Every week, I clean out the fridge and make or plan meals with things that need to be used up. For example, at the end of summer we have a ton of zucchini from the garden, so there will be zucchini soup, stir fry, and zucchini bread on the menu. Dinner often uses leftover meat for Taco Tuesday. It doesn't matter if it's hard tacos, soft tacos, quesadillas, taco salad or nachos, this is the theme we use for each Tuesday night.

Tuesday is also when I'll do an inventory of the fridge, freezer, pantry, and dry storage (things like onions, garlic, lemons, avocados, and potatoes). During my fridge prep, I will freeze any leftover soup for quick lunches during the week. (This is the homesteading version of fast food.) I love clearing the fridge on Tuesday since our garbage is picked up early on Wednesday morning.

When we first up moved up here, I was all excited about composting our food scraps.

But you know who else would be so excited about us composting our food? Bears. And with a garden, chickens, and an outdoor pantry, we don't need anything else up here that makes bears think this would be a great place to stop for dinner.

So instead, we invested in an indoor composter called Lomi that sits on our counter and turns our food waste into clean garden compost. It's a great way to dispose of most of our food waste and keep our garbage as "clean" as possible.

(By the way, know what's the best trick for keeping bears from rifling through your garbage cans for bones or other stray food that ends up in there? Spray the garbage bags with Windex. The ammonia smell makes the bears less interested in what's inside.)

Now that I know what is in the fridge, what needs to be used up, and what will keep for a while, it's time to figure out our menu for the weekend and the coming week. Wednesday and Thursday are our two wild card nights. One night we'll most likely eat out, and the other night will be a Trader Joe's special. (We love their orange chicken, honey walnut shrimp, fettuccine alfredo, chicken chow mein, and vegetable Pad Thai.)

With my meal plan settled, I can now look at what we need to refill in our fridge, freezer, pantry, and dry storage. I make a shopping list to replenish what we are running low on, not necessarily to get ingredients for a specific recipe.

Wednesday: Shopping

Wednesday is our day to go into town and restock the larder. I prep by taking my shopping list, a cooler (or two in the summer), blue ice packs to keep everything cold for the long trip home, shopping bags, and water and snacks for the trip. This is also our day to splurge and get some great takeout food that is better than what I can make at home. Think Thai curry, any combination of Chinese food, pizza, or sushi. Because after I've shopped, returned home, and put away all the groceries, the last thing I want to do is cook. I want to eat a California roll while watching other people cook on the Food Network!

Friday or Saturday: Cooking Day

This is the day we've been waiting for—cooking day. I will make dinner for Saturday night, soup for Sunday lunch, and anything else that will help feed us Saturday through Tuesday. I always start my soup first so that the flavors have time to meld. Almost every recipe or soup idea starts with a chopped onion sautéed in the bottom of my red Lodge Dutch oven with a little bit of olive oil. After that, it's just building layers and flavors and texture with all the tools (and food) I have at my disposal.

Sunday: Rest and Eat

Your work is done. Enjoy the soups of your labor!

HOMESTEADING PRINCIPLE

Learn to Leverage What You Have

Our version of fast food here on the mountain is a Costco chicken. We'll buy one chicken and eat it two or three different ways.

Wednesday we run errands in town, and by the time we come home and unload the groceries, supplies for our next project, water bottles for our water dispenser, food for the dog, cat, and chickens, and packages we've had delivered to my mom's house (because no one can find our house in the mountains), we are more than ready to eat dinner. If we haven't splurged on takeout, we probably have a roasted chicken from Costco. Add in a bag of salad and a loaf of bread for the fastest meal ever. It's delicious, and dinner is done—and done is better than gourmet when you're hungry. We eat the roasted chicken. Like savages.

But there are just two of us, and that's one big chicken. So I often chop up the leftover chicken and use it in chicken and wild rice soup.

It is divine.

This soup, served alongside a romaine salad with an oil and vinegar dressing and some leftover bread from the night before that we've put under the broiler with a little oil and parmesan cheese? It will make you weak in the knees.

Like all my soups, I cook it on Saturday, let it simmer, then let it cool down. I put it in the fridge on the "soup shelf," which is a shelf in my fridge that I have adjusted to fit my Lodge stockpot. Then it's ready and waiting for us the next day.

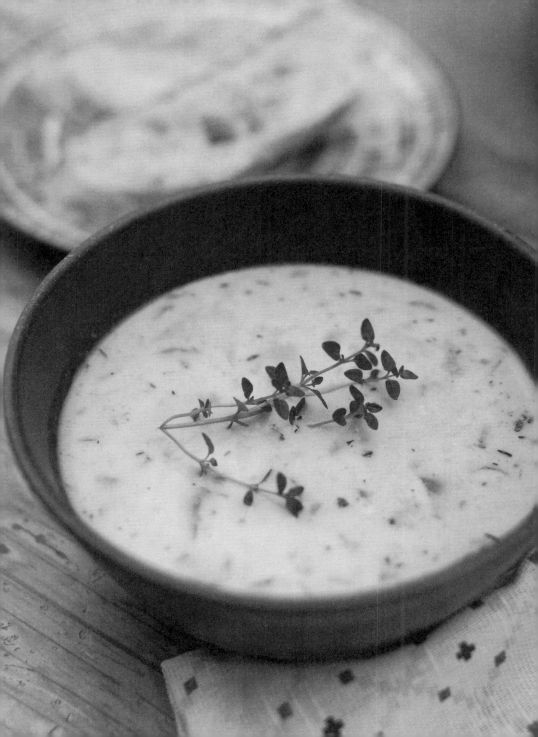

Chicken and Wild Rice Soup

Ingredients

6 T. unsalted butter
3 celery ribs, chopped
2 carrots, chopped
1 medium yellow onion, chopped
2 garlic cloves, minced
½ tsp. fresh thyme, finely chopped
½ tsp. rosemary
Salt to taste

Pepper to taste
¼ cup all-purpose flour
1 cup uncooked wild rice (5 ounces)
2 quarts chicken stock
2 cups water
4 cups cooked chicken, chopped
1 cup heavy cream

Directions

1. Melt the butter in a large stockpot over medium heat. Add the celery, carrots, onion, garlic, thyme, rosemary, salt, and pepper. (I start out with ¼ teaspoon each of salt and pepper and then adjust to taste while the soup is simmering.) Cook about 10 to 12 minutes, stirring occasionally, until the vegetables just start to soften. Sprinkle the flour over the vegetables and cook, stirring, until the vegetables are evenly coated and lightly browned, about 3 to 5 minutes.

2. Add the wild rice to the saucepan, then gradually stir in the stock and water. Bring to a boil, then simmer over medium-low heat, stirring occasionally, until the vegetables are tender, about 30 minutes.

3. Add the chicken and simmer, stirring occasionally, until the wild rice is tender, about 10 to 15 minutes. Season with extra salt and pepper if needed.

4. Stir in the cream just before serving.

Makes eight bowlfuls.

This soup can be refrigerated for up to two or three days. Just reheat it on low and serve it with your favorite salad, bread, or other side.

Like all of our soup recipes, we share it with our neighbors, or reheat it on Sundays so we don't have to do any cooking on our Sabbath, and maybe eat it again on Monday for a "fast food" on our busiest day of the week.

This is one of my favorite winter soups. I promise, you'll get raves from anyone you are feeding, and you'll never again wonder what to do with leftover Costco chicken.

❊ SPRING ❊

In the suburbs, spring was never one of my favorite seasons. There just wasn't anything special about the season that made it stand out.

But here on the mountain, as a homesteader?

It's all about the spring. (Okay, and fall, but that's a different part of the book . . .)

After a long, sometimes dreary winter, any level of homesteader is just itching to work on all the projects they have been dreaming up all winter. Winter is a dangerous time for any homesteader because while it's harder to be outside, and some tasks have to wait until spring, it's easy to let your dreams for your homestead take over your budget, abilities, and common sense.

But plans and patience are your greatest assets as a homesteader.

You have planned your garden and want to get all those seedlings in the ground so you can start eating fresh tomatoes as soon as humanly possible. But you must be patient because spring will start to lull you into a false sense of security and say, "Don't worry about me. I definitely will behave myself and not let it get cold again . . ." And then—*bam!*—a frost comes, and all your plants need to be ripped out and replaced. And this time, you will lose homesteader bragging rights ("Why yes, I did grow that from seed . . .") because you will have to go to the gardening section of Home Depot to get your plants.

So make your plans and then be patient. The hard work of late spring will come soon enough, and you will miss those days of being stuck in your house leafing through seed catalogs and longing for the days of work.

We're Building
Something Here

O ne of the big challenges of homesteading, or whatever it is we're doing, is our constant desire for expansion.

We came from a townhouse in Silicon Valley that was 1,400 square feet. When we were looking at homes, Roger wanted a little space to move around in. He thought getting a house with an acre of land would be great since we came from a situation where we literally shared a wall with our neighbor.

Looking at the Zillow listing for the Red House, I saw that it was on a little more than eight acres. "Roger, what are we going to do with eight acres? That's crazy!" But Roger assured me we were up for the challenge.

During our tour of the house—which I immediately fell deeply in love with—the owners, who were home during the tour, asked us if we planned on taking the additional twenty-four-plus acres.

"Um . . . what twenty-four acres? And: No."

Come to find out, they were not only selling the house and the eight acres it sits on, but also the adjoining twenty-four acres.

"No. Just no." I kept repeating. We didn't need what is the equivalent of twenty-five football fields. With trees. No thank you.

But then Roger said, "What if someone buys that land and builds something terrible on it? What if they ruin our view? I think we should get the land." And because I wanted the house so badly, I went along

with his insane plan. And now we are the ill-equipped owners of thirty-three-ish acres.

Having so much land sometimes inspires a deep desire to build on it. It's amazing what land ownership will do to a soul. It stirs something inside of you. Not only do you want to own that land, you want to tame parts of it.

Now, don't get me wrong—there is still plenty that is untamed on our property. All of the twenty-four additional acres are undeveloped, save a now-collapsed gold mine that was active until the 1970s.

My husband, who had never built anything beyond a flower box in his entire life, suddenly found his inner Bob Vila (or Ty Pennington, or Chip Gaines, depending on your generation) and started building.

I was a bit skeptical at first about Roger's building plans. My husband is one of the most capable humans I've ever met, but the first fifty or so years of his life were dedicated to building computers and code. There had been a minimum amount of hammer swinging.

But on our eight acres? We're building.

It started when I wanted to run to IKEA to grab a desk for Roger's office, but IKEA was closed at that time because of COVID. Something inside Roger came alive and he said, "Let's grab the lumber and I'll build a table."

At this point in our marriage, the most complicated thing I'd seen Roger build was extra toppings on a pizza, so I legitimately had my concerns.

But Roger got the wood and built a beautiful indoor desk.

Since I was beginning to understand this particular set of skills, I showed him a picture of an extra-long outdoor table—one we could hang lights over. I imagined a dozen friends and family sitting around it, talking and laughing long into the night.

Roger built me my dream table. And we do sit around it under the stars and lights with friends and family, talking long into the night.

Then Roger progressed to building the chicken coop from a kit. (The

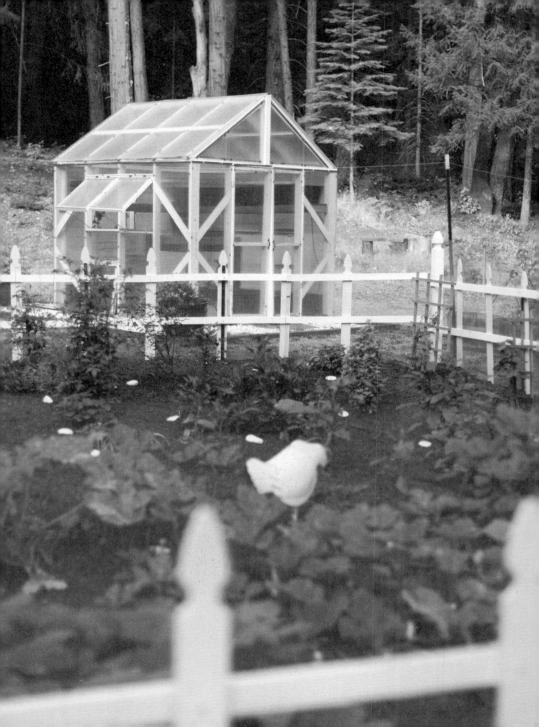

world's most confusing kit, but I digress.) After that, Roger designed and built our chicken run, the enclosed area adjoining the coop where the chickens can be outside and protected at the same time.

Because that didn't feel like enough, we kept adding chickens. We started with four, and then one passed away, so we added two more because we wanted the new lady to have a buddy. Anyone who has kept chickens knows about chicken math:

You start with four chickens and notice that you have room for two more.

But baby chicks are small, so you get six chicks and tell your husband he has five weeks to build a bigger coop.

And you hate the idea of all those chickens being crammed in a coop, so your husband builds them a chicken play yard.

It's a sickness. Really.

And then Roger, catering to my homesteader complex, took my casual musings about wanting a greenhouse and built me the greenhouse of any homesteader's dreams. It has planters where I can grow tomatoes, cucumbers, squash, and peppers, and it has shelves where I can start seeds and prepare smaller plants for the garden outside the greenhouse.

It's amazing what you can accomplish with a little space and a dream, even without much prior knowledge or experience.

Push Through to the Joy

Roger and I are both firmly in our fifties. We have our professions, and we are pretty competent at what we do.

But homesteading makes us feel like beginners at every turn.

For Roger, it's woodworking, home repairs, tilling, forest management, using big machinery, and doing all the outdoor things that keep this land running.

For me, it's gardening, raising chickens, preserving food, making home repairs, and doing all the things to keep the household running. We have plenty of opportunities to feel like we have no idea what we are doing.

But we also get to experience the joy—the pure, magical joy—of completing a project we never dreamed we would be able to complete.

Turns out, often all you need is a can-do attitude and a lot of YouTube videos.

As you take on a new dream, here are a couple of things to consider:

1. Learn as much as you can on your own.
2. Find compassionate experts (and be willing to compensate them for their time).
3. Whatever your timeline is, double it.
4. Whatever your budget is, triple it.
5. It's okay to have high hopes, but keep your expectations low.

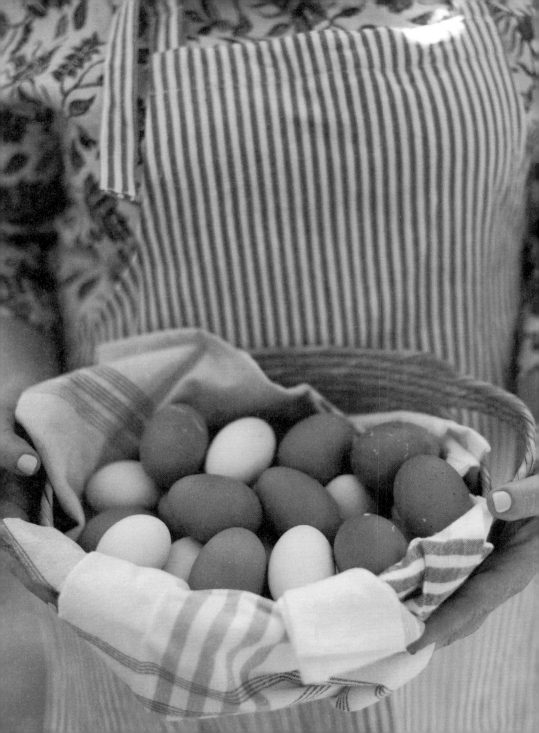

Use It Up

*A*ll winter long, we are just waiting for our chickens to start laying eggs again. You see, in winter, our chickens' egg production goes way down. (And there is no greater shame as a homesteader than having to buy eggs.) We are lucky to get one or two a day. But sometime in March, as the days start to warm up, the girls go into production. (I say start to warm up, because one year we had a snowstorm right in the middle of April.)

There are days we will go out to the nesting boxes to discover that all the girls have been productive and there are five eggs waiting for us. This is still so exciting to us that whoever gathers the eggs will announce to the other, "Three brown, two blue!" because we still can't believe we have chickens and they actually lay eggs!

One of the main principles we have as pseudo-homesteaders is that as much as humanly possible, nothing goes to waste. We live by the old adage, "Use it up, wear it out, make it do, or do without."

So we love to have eggs for breakfast, hard-boiled eggs on our salads, and sometimes even a fried egg on our hamburger to be extra fancy. But the two of us cannot eat twenty-five eggs a week.

We do give some away to neighbors and friends, of course, but one of our favorite ways to put those eggs to work is in an angel food cake.

Angel food cake is one of the most magical recipes we have around this place. It not only uses up a bunch of eggs (nine, to be exact) but also

uses up the berries we either grow here on the property or buy at Costco (depending on the season, how successful we are at gardening, and the local deer's ability to navigate our garden security system—a.k.a. fences).

This recipe comes with a warning: Once you make it, you will never again be satisfied with the angel food cake you get at the supermarket.

How to Keep Berries for a Really Long Time

Here on the mountain, we grow strawberries, blueberries, and raspberries, and we also have hundreds (thousands?) of blackberry plants that grow wild. Each year we have a blackberry picking party with wicker baskets, picking arms, and machetes. (Yes, those bushes are thick, prickly, and hard to manage.)

And I tell you, nothing makes you feel like more like a homesteader than wielding a machete on the land.

We use some of those blackberries to make jam and syrup, but the rest end up fresh on our oatmeal, yogurt, and angel food cake.

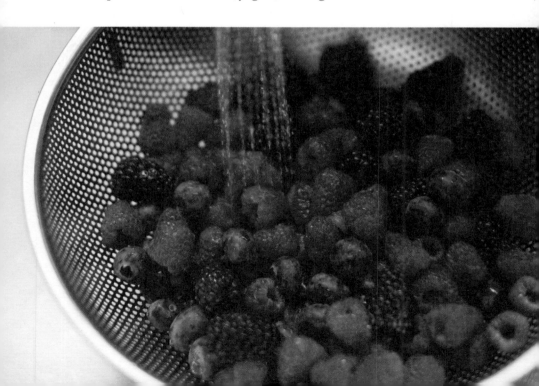

One of the most important skills we learned up here was how to make sure our berries lasted as long as possible. I used to leave our store-bought berries in their containers, wash them as I was using them, and then throw the whole pack out once I started to see mold. But I've learned how to make my berries last two or three times longer. It's a simple process, but it's so important when you're able to go to the store only once a week or when a whole crop of berries ripens at the same time.

1. *Rinse the Berries*

 This is especially important if you are washing home-grown berries. You'll want to get the most dirt (especially big chunks) and the occasional tiny bug off your berries.

2. *Wash the Berries*

 Once the berries are free of dirt and bugs, wash them in a large bowl filled halfway with cool water and a cup of vinegar. Submerge the berries for 15 minutes, then ladle them out and rinse them in a colander. You can reuse the vinegar water to wash multiple batches of berries and other fruits and vegetables. Just change it out when it starts to look discolored.

3. *Dry the Berries*

 Let them drain in a colander for 30 minutes, then plop them on a towel and let them dry completely for a few hours.

4. *Store the Berries*

 Place the berries in glass containers (canning jars work great, but so do glass storage containers), where they will last for up to two weeks. (I've had some last even longer.)

5. *Or . . . Freeze the Berries*

 Once the berries are completely dry, you can freeze them. Put them in doubled-up plastic bags, then lay the bags on a cookie sheet and place them in the freezer. This prevents them from freezing in a big clump. Once frozen, the bags can be stored flat or upright.

Angel Food Cake

Ingredients

1 cup cake flour, sifted
1 ½ cups sugar, divided
9 egg whites

¼ tsp. salt
1 tsp. cream of tartar
1 ½ teaspoons vanilla

Directions

Preheat the oven to 330°.

1. Sift together the flour and ½ cup sugar. (I use a mesh colander since I keep breaking my sifters.)

2. Beat the egg whites until foamy.

3. Add the salt and cream of tartar and continue beating until the whites form soft peaks.

4. Beat in the remaining cup of sugar and the vanilla extract until stiff peaks form.

5. Fold the flour mixture into the beaten egg whites.

6. Turn the mixture into an ungreased angel food cake pan. (I prefer a pan that has a removable floor to make it easier to get the cake out.)

7. Bake 45 to 55 minutes until an inserted toothpick comes out clean.

8. Invert the cake on a cooling rack. If the cake needs a little persuasion to come out, run a rubber spatula around the sides of the pan.

8 to 12 servings

Serving Suggestions

1. Slice the cake into 8 or 12 portions (depending on how many servings you need). We top the cake with whatever berries we have on hand. Strawberries, blueberries, blackberries, and raspberries are our favorites.

2. In the winter we will drizzle the cake with dark chocolate syrup and top it with bananas and slivered almonds.

3. You can also slice the cake in half horizontally. (I use unflavored dental floss and leave it on the tube part of the tube cake pan while slicing.) Set the bottom half of the cake on a platter, top it with berries, add the top half, and frost it with whipped cream. This works only if you are serving the cake immediately.

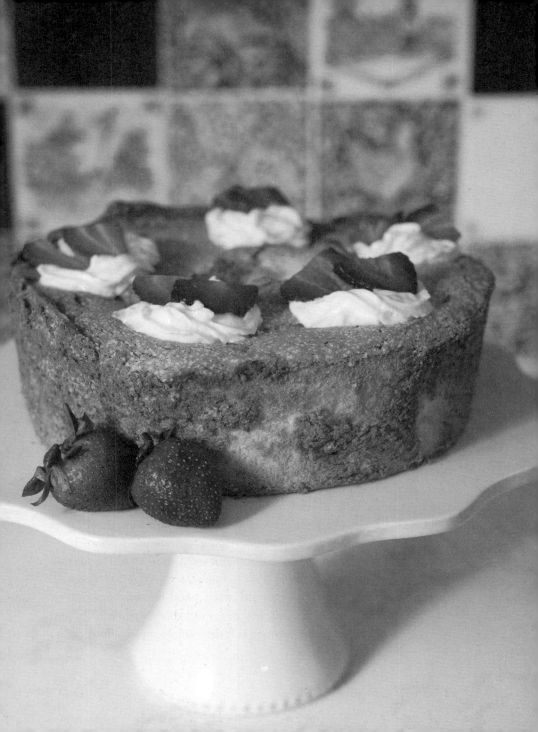

How to Keep Track of Everything You Need on the Homestead

(and There Are So Many Things . . .)

It is astounding how much stuff I didn't know we needed in order to survive as pseudo-homesteaders.

We moved from a 1,400-square-foot house in the Silicon Valley to a 3,000-square-foot house on 33 acres. And never in our lives have we been so worried about running out of space.

If you've read one of my other books, it was probably about decluttering. My dad was a hoarder, and I have definitely leaned to the side of having way too much stuff. But I've worked hard to tame my cluttery ways, and I've made it my life's purpose to help others do the same.

That doesn't mean my heart won't look for ways to keep more stuff if given the opportunity. And there is nothing that will lend itself to wanting to keep every bobbit and whosit more than a homestead—even a halfway homestead. Because on a homestead you can find a use for absolutely everything. Old sheets? Perfect for painting projects. Empty plastic bottles? Those make great greenhouses for starter plants. I've even seen some farm fashionistas turn their chicken feed sacks into purses.

So how do you not let your house become overrun by everything you need on a homestead?

Dedicate a Space

Each space has a purpose, and you have to determine the purpose of that particular space. Some of our spaces, like the attic and barn, have wild temperature swings, so we have to be very deliberate about what we store there. Also, those of us who live in the mountains have to consider what the critters can get into when we're choosing where things should be stored.

You may be called on to use storage in ways you wouldn't if you were living in the suburbs. For example, because we need to keep a lot of food on hand, especially in winter, our pantry is in the garage. We keep extra for emergencies and also just so we don't have to run out to the supermarket because we ran out of baking soda.

The garage has some temperature swings, but it doesn't get nearly as hot as the attic. Food can handle getting too cold much better than getting too hot. Plus, we need to keep everything except canned and jarred food in sealed tubs so that no fuzzy visitors will decide our garage is the next place to have their rave.

I've listed below some of the categories you're going to need to have a dedicated space for on your mini (or not so mini) homestead.

Food

You will need to keep more food on hand than you did in the city or suburbs. Anywhere you are homesteading is probably much farther from town than you're used to. Not only will you want to go to town less (because every trip to town means less time to make your homestead awesome), you'll want to stock up on those things you end up using way more than you ever did when living in town. For us, it's chicken stock. Gallons of chicken stock.

Now, if you are a real homesteader (one who is growing the majority of what you are eating year-round), you will also need to have lots of space dedicated to things like canning supplies, food storage containers, an extra freezer, long-term food storage, a food dehumidifier, room for drying vegetables and herbs, a composting bin, seed storage, and shelving for

everything you are "putting up." For those of us who still go to Costco at least once a month, you just need a place to put your haul.

Besides our kitchen refrigerator-freezer, we also have an extra fridge-freezer combo in the garage that is plugged in only when we host retreats or have lots of guests. There's also a chest freezer we fill up in the fall and winter and eat out of in the spring and summer.

Tools

Yes, you will need equipment you've never even heard of before. Tools will become as desirable as the designer shoes you used to drool over when you lived in the flatlands. Here are just some that you might need, depending on your unique homestead:

log splitter	post hole digger
snowblower	snow shovel
chipper	mosquito abatement
chain saws	solar panels
(yes, that is plural)	solar batteries
string trimmer	walkie-talkies
axe	emergency radio
wheelbarrow	emergency lighting
lawn mower (we have both	tiller
a riding and a push version)	gloves (work and gardening)
truck or trailer	table saw
ATV (yes . . .)	hammer
power washer	handsaws
circular saw	screwdrivers
T-posts	drill
chicken wire	knives and scissors
earth auger	gardening tools
zip ties (these will become	
your best friends)	

You will also need a place to put all those tools. Trust me on both of these points.

Gardening Supplies

In Silicon Valley we lived in a townhouse, so all I had was a patio garden and my supplies for this particular activity were minimal. The equipment we now need for gardening is significant. Between the bags of soil, gardening tools (yes, more tools), containers, seed storage supplies, heating mats, and lamps, it requires a lot of storage space.

Bedding

In the city, we had two sets of sheets, one blanket, and one comforter. Here? Double all that, and throw in an electric blanket and an extra quilt. Since we don't have central heating or air, much of our comfort is determined by layers.

Clothing

Speaking of layers, you are going to need So. Many. More. Clothes. (And no, I'm not writing this just as an excuse to shop. Promise.) You will need winter clothes. Ski coveralls. Giant boots. Old jeans. Cute jeans (because you will leave the house—just not as often). Most of your clothes will have dirt on them. And poop. (Oh . . . so much poop . . .) And they'll be covered with food from all the cooking you will be doing, because I'm guessing DoorDash doesn't deliver to where you are.

Think of all these categories as running a mini-business, even if that business is just keeping you alive. Each business has to stock certain things to function, and homesteading is no different.

Declutter

With all you need to procure to support a homesteading lifestyle, it is essential that you let go of some things you are no longer using.

Every year, I get a little braver and get rid of more knickknacks I no longer love, clothes I no longer use, and books that are not relevant to my life anymore.

In my book *Clutter Free*, I talk about the three questions I ask myself when I'm deciding whether to keep something:

1. Do I love it? (And if so, is it hiding in a box in the garage? Is that truly love?)

2. Do I use it?

3. Would I buy it again?

If I can't give a wholehearted *Yes!* to at least one of these, I need to seriously consider getting rid of it.

HOMESTEADING PRINCIPLE
You Are More Creative Than You Think

The good news about homesteading and decluttering? Homesteaders, we are a creative bunch. I can't tell you the number of times I've substituted an ingredient for a recipe or reverse engineered a recipe to use up a bunch of ingredients I already have.

You don't have to get everything at once. If you don't have the room or the finances for something, you can rent it, borrow it, or buy it used. And then resell it if you only need to use it once and don't want to store it.

You will figure out what you need, what makes life better, and what you don't need anymore. For me, that is most of the "business" clothes I had in the city. The chickens don't care if I'm "on trend."

If you're just getting started in your homesteading adventure, like we were five years ago, go slow. Get what you absolutely need and save up for the rest.

You've got this.

Spring Cleaning

(and Why You'll Actually Want to Do It in the Spring)

*A*homestead is hard on a house. And on its humans.

I never really understood the idea of spring cleaning when I lived in Silicon Valley. Why clean specifically in spring? But now, living here on the mountain, I get why spring is the time a girl's fancy turns to industrial mops and Scrub Daddys.

Our mountain house takes a beating in the winter. The windows are dingy and the floors can't stay clean. Just bringing in wood to stay warm takes a "Cleanup on aisle seven!" every single time it happens. The outside of the house needs a good scrubbing after winter snow and rains. The kitchen is constantly in use. And in the winter, there are so many tasks that need to be done just to keep life in motion that some of the bigger cleaning tasks just fall to the side until the yard and I thaw out.

In the spring, you just want to start fresh.

I'm offering this list not as a "If you're a good homesteader, here are the things you will make sure you're on top of" kind of list. No. I offer this list in the hope that it will help you decide what needs to be done and what can be ignored.

So much of homesteading is living out the adage, "A stitch in time saves nine." In other words, if I clean out the crumb tray now, I can avoid my house smelling like burnt toast for the next six months. Or if I clean

out the fridge now, I can have that meat for dinner tonight instead of throwing it out on Saturday because I forgot about it.

Before we get into the spring cleaning list, here are a few items that will make your cleaning so much easier:

- Indoor/outdoor rugs: Our kitchen door leads outside, which means we track a lot of "organic matter" into the kitchen. We put an indoor/outdoor rug in the kitchen that is easy to clean quickly.

- Heavy-duty doormats: It's fun to get cute doormats, but as a homesteader, what you really need are doormats like they have in front of major office buildings.

- Industrial mop: Swiffers are great for quick cleanups, but when it comes time for deep cleaning, you need a mop that is geared for heavy-duty work.

- Carpet guards: The only place we have carpet is on our stairs, so we've purchased some "stair treads" to put on each step to keep them clean. Our first thought was to get stairs that were hardwood, but we know too many people who have slipped going down the stairs. And I am not known for my grace, even on my best days.

- Buckets

- Long-handled duster

- Cobweb catcher (with extended pole)

- A stack of cleaning rags

Start at the Top

Here's a cleaning principle I follow: In each room, start at the top and work your way down. There is nothing more frustrating than mopping a floor, only to clean off the top of a dusty cabinet and then need to re-mop.

My hope is that there is a big chunk of this list you can totally ignore. But if you are feeling the need to do a deep clean, here are the areas you may want to consider.

Kitchen

- Dust the tops of cabinets. (I love a duster with a long, extendable pole.)
- Clean behind the fridge and freezer. (Airflow is important to keep your appliances energy-efficient and running smoothly.)
- Declutter under the sink and toss any cleaning products you are not using.
- Move old sponges or dishcloths out of rotation. (Mine go from being used in the kitchen to being used outside.)
- Clean your oven.
- Descale your coffee maker.
- Empty your cabinets one at a time and wipe down the shelf linings. (Don't pull everything out at once. It's easy to get overwhelmed and sit there with six cabinets worth of stuff on your kitchen table. Do it one cabinet at a time so you can easily stop and start again.)
- Clean the front of your cabinets. (Don't forget the tops of your cabinet doors.)
- Clean your carpets, area rugs, throw rugs, and doormats.

Living Room

- Dust the ceiling fans, light fixtures, and lamps.
- Dust all woodwork, windowsills, and furniture.
- Clean light switches.
- Vacuum couches.
- Spot-clean couches.
- Wash rugs.
- Clean out anything used to hold firewood and kindling.

Bedrooms

- Dust ceiling fans, light fixtures, and bedside lamps.
- Dust all woodwork, windowsills, and furniture.
- Clean light switches.
- Strip beds and wash all the bedding, including mattress pads and protectors.
- Vacuum mattresses.
- Flip or rotate mattresses if possible.
- Vacuum or sweep under beds.
- Wash rugs.

Bathrooms

- Wash walls, tub, shower, fixtures, sink, and toilets.
- Wipe down towel racks, doors, cabinets, countertops, and mirrors.
- Declutter under the sink.
- Bleach white towels, hand towels, and washcloths. Or if you are on a septic tank, choose a chlorine-free bleach alternative.

Laundry Room

- Fill the washing machine drum with one cup of baking soda and one quart of vinegar and run a wash cycle with four white towels. Use the hottest setting, the largest load setting, and the longest wash cycle. This will do a great job deep cleaning your washing machine.
- Clean the dryer vent.
- Vacuum behind the dryer.
- Wipe down the washer and dryer.

Septic System

This is a good time of year to remember that your septic tank may need to be checked and pumped by a professional. (I'm sure there is a DIY way of doing at least the checking, but this is something I'm willing to pay hard-earned money to let a professional do.)

Some additional cleaning products you may want to consider having on hand:

- *Carpet cleaner:* We never had one of these when we lived in the flat-lands, but here you can't just rent a cleaner and then take it back to the store the next day. (Well, I guess you could, but it's a long trip.)

- *Dish rack and tub for the sink:* When the power goes out and your dishwasher no longer works, you'll be glad you have a setup to wash dishes as you go. (By the way, even when there is no power to your dishwasher, you can still use it as a giant dish drying rack. Please don't ask me how long it took me to figure this out . . .)

- *Shop vac:* Life is dirty on the mountain, and your house vacuum can't handle everything you will be tracking in.

Be Open to New (and Better) Ways of Doing Things

It can be frustrating to do something one way your whole life and then discover it doesn't work anymore. Please remember that if you are making a right turn in your life and diving into homesteading, especially after age forty, you are learning every single day. Your brain is getting new folds while other people are thinking about things like "slowing down" and "taking it easy." You, my friend, are just getting started all over again.

And this is a very good thing.

1. You always have something fascinating to talk about with your friends. (I mean, who isn't riveted by discussions of cannibalistic chickens?)

2. It keeps you young. Okay, maybe not your body (which spends a lot of time hurting), but being a lifelong learner keeps your mind and your spirit young.

3. Life stays interesting when you're learning. We have never once been bored here on the homestead. And we intend to keep it that way. There is always a new project, a new idea, or a new challenge. We spend a lot of time on YouTube and Pinterest trying to figure out how to DIY instead of "calling the guy."

4. The more you learn, the easier it gets. We are so much better equipped than we were five years ago. It does get easier. And then you can start helping others, which is a lot of fun.

DIY Laundry Soap

I'd heard of several people making their own liquid laundry detergent, but there was mixing and boiling involved and I thought, "Ugh. No thank you." (Just because you're a wannabe homesteader doesn't mean you have to do everything the hard way.) But ever since I read how much people were saving by making their own detergent, whenever I picked up the expensive, giant tub of suds at Costco, I thought about how I could buy three Costco whole roasted chickens for the same price.

When I saw a couple of people come out with this powdered laundry detergent recipe, I knew I had to give it a try. It smells great, works great, and is super easy to make. I got all the ingredients for under thirty-five dollars—and it lasted at least six months, even when we still had three kids living at home.

The first question everyone asks me is whether it's safe for HE (high-efficiency) washers. All I can say is that I have scoured the internet looking for anyone who has had a problem with it and have yet to find someone. Plus, all the individual ingredients are safe for the washer. The main concern is that for HE washers, you want a detergent that is less sudsy. I've sat there and watched my laundry go through a cycle with a store-bought HE detergent and also with this homemade version, and the sudsing was identical. (And no, apparently I don't have better things to do with my time.)

But if you are of the super-paranoid variety—or are married to someone who is—buying laundry detergent for about twelve dollars a month is a small price to pay for peace of mind.

My hubby is super skeptical of "alternative" anything, but even he was convinced to give this a try. We've been using this recipe for more than ten years and have never had a problem with it.

Homemade HE Laundry Detergent

Ingredients

3 (5 oz.) bars Fels-Naptha, grated

1 (76 oz.) box Borax

1 (55 oz.) box washing soda

2 cups baking soda

2 (3 lb.) containers Oxyclean

1–2 (28 oz.) containers Purex fabric softener crystals (one bottle was plenty of smell for my gang!)

Note: All these ingredients are available on Amazon and at Walmart, but I also have found some of them at dollar stores, which keeps the price super low.

Directions

1. Start by grating the Fels-Naptha. Most people do this with a hand grater, but the soap is not that hard, and you can use a food processor to grate it. If you want it more grated, you can use a different blade, but I prefer mine to have the cheesy look. (Okay, I don't really care how it looks—this is just faster.)

2. Next, mix the grated Fels-Naphtha soap and the rest of your ingredients together. Some people like to mix it right in the tub where they are going to store their soap. To make sure the ingredients get completely mixed together, I use a big black garbage bag to line a bucket and pour everything in there. Then I gather

the top of the garbage bag and keep tossing all the ingredients over and over until they are fully mixed before dumping the finished product into my container. But a warning: Do this outside! All that powder can be a lot to breathe in.

3. *Voila!* Store your soap in a sealed container with a scoop.

I like to transfer what I'll need for a month into a smaller jar to keep in my laundry area. I use two tablespoons of detergent for every load of laundry. I also make sure to put the detergent *directly into the tub*, not the detergent dispenser.

There are so many things I love about this homemade detergent. It is the ultimate Accidental Homesteader way to do laundry:

- Custom: Roger likes a light scent when it comes to laundry soap. I use less of the fabric softener crystals for a less intense smell.

- Cost: Making my own detergent saves me between $80 to $100 every six to nine months. Never running out of laundry soap? Priceless!

- Less plastic waste: Fewer containers for the landfills is better for the environment.

- Less lugging: I hate with a fiery passion lugging all those giant items home from Costco, but I love that I can pick up these small items and keep the tub in my garage.

Drying

The ultimate homesteader laundry experience—in addition to making your own laundry soap—is hanging your clothes to dry.

There is nothing that smells better than laundry dried on the line. And with the possible exception of towels so crisp they could cut a log of goat cheese, there is really no drawback to drying clothes outside three out of four seasons.

1. It keeps our house cool. We still use our dryer in the cooler

months, but when our house is the hottest, I have no desire to add to the temperature.

2. Did I mention clothes dried outside smell amazing?

3. It cuts down on the power bill.

We don't have a great setup for an old-fashioned clothesline on our property, but even when we were living in a townhouse in the middle of Silicon Valley, we were still able to hang dry a lot of our clothes. Consider the different setups that might work for you when it comes to hanging laundry:

- *Drying rack for small items:* We have a collapsible drying rack that is perfect for washcloths, hand towels, kitchen towels, and small clothing items, like socks and underwear. With a little creativity, we can fit a lot on that one rack.

- *Drying rack for hanging items:* You can buy drying racks for hanging items. I used a collapsible, portable tripod drying rack for years . . . until it fell over one too many times in the wind. I guess it was advertised as an indoor drying rack for a reason.

- *Drying rack for large items:* We use a foldable gullwing laundry rack for towels, jeans, and other larger items.

- *Outdoor clothesline:* If you have two poles or sturdy trees, you can tie a rope between them for an old-fashioned clothesline. All you need are some wooden clothespins and a wicker basket, and you are ready to live out your homestead fantasies! Make sure the clothesline is thin enough to hold the clothes with clothespins attached but sturdy enough to keep from drooping.

- *Expandable clothesline:* If you've been on a cruise or in a moderately priced hotel, you've seen these. They are attached to one of the shower walls and have a receiver on the other end of the shower. You can pull the line from one end of the shower and attach it to the other end and hang light clothes on the line.

- *Shower rod:* I use our shower rod for much of my drying twelve months out of the year. Just pull the clothes from the washer, hang them on a hanger, and let them dry overnight. Everything usually gets dry, with the exception of Roger's jeans, which sometimes need a few extra hours. I hang our wash after the last shower of the morning and gather all the dry clothes the next morning to take upstairs. Or to be extra efficient, I just pick my outfit from what is now dry and hanging from the shower rod.

Make sure you have plenty of clothespins and extra hangers.

And forget every movie where women are tearing the clothes off the line because a rainstorm is coming. Just leave them there. They will get wet. But they will also get dry the next warm day.

HOMESTEADING PRINCIPLE

Adapt

My drying situation is going to look different from yours. Maybe you get more rain than my Northern California homestead does, or maybe your chickens like to perch on your freshly cleaned clothes. There is almost always a way to make your situation work with a little research and creativity. Know your options, be willing to adjust, and just keep trying out different methods until you find the one that works best for you.

Next-Day Chili

call this "next-day" chili because when I'm trying to decide what to do with chicken or turkey the day after we have it, this is a great way to use it up. So much of homesteading is using what you already have. There is nothing more defeating than having delicious food going to waste. It's a total pride issue for me that I do not waste an ounce of food. (Of course, I have a cheat that I can throw 99 percent of any food to our little velociraptors—the chickens.)

In the spring, I'm still waiting for all those glorious veggie plants I've put in the ground to actually produce, and we are eating down what we have in the freezer from the winter stockup. This simple but delicious recipe is perfect for that in-between time, as it uses a lot of canned items, which we always have on hand.

Chili may not feel like a "spring" meal to some, but as I write this, smack-dab in the middle of April, we are in between two snowstorms. So tomorrow, Saturday, I will be making my chili, taking some to our neighbors, and then eating it for our next couple of meals. Sunday I'll serve chili straight from the reheated soup pot with shredded cheese, sour cream, and green onions. Monday's lunch will be baked potatoes topped with chili, cheese, sour cream, and chives. Tuesday's dinner will be chicken sausages, potatoes, and veggies topped with chili. By Wednesday we will be grateful for but done with chili and will move on to another kind of meal.

Next-Day Chili

Ingredients

1 T. vegetable oil

1 cup chopped onion

1 clove garlic, minced

1 (6 oz.) can tomato paste

1 (16 oz.) can stewed tomatoes

1 (16 oz.) can kidney beans, drained

1 (16 oz.) can tomato sauce

3 tsp. chili powder

½ tsp. basil

¾ lb. leftover chicken or turkey, shredded

Shredded cheddar cheese

Sour cream

Directions

1. In a large soup pot, heat the vegetable oil and sauté onions and garlic until the onions are translucent. Stir in the tomato paste to coat the vegetables.

2. Add in undrained tomatoes, drained kidney beans, tomato sauce, chili powder, basil, and pepper. Cook on low for at least an hour, so the flavors can meld. Add the leftover chicken or turkey and heat until warm, about 15 minutes. Top with the cheese and sour cream to taste, and serve with cornbread and a salad.

4 Servings

I always double the recipe so we can feed friends and neighbors, make it last for a few meals, or put some in the freezer for homesteader fast food. You can also use leftover chili for taco salad (just add lettuce, fresh tomato, tortilla chips, and cheese), use chili to top burgers or hot dogs (maybe add some diced onion), or try chili on quesadillas or nachos.

❄ SUMMER ❄

Summer is the time at the Red House where we can pretty much predict the weather and plan accordingly. Forecast: hot. The rhythm of our life changes in summer.

Early summer is when we have a stream of guests looking to take advantage of the fresh air, see the mountain at the peak of its beauty, sleep with the windows wide open, and enjoy long nights sitting outside with no streetlights to obstruct the view of the most beautiful stars you have ever seen.

Summer is when we start to see everything that has been planted in the garden and greenhouse take on a life of its own. We start to see blooms on some of the plants and veggies. We can even harvest some of the early tomatoes and basil, pair it with homemade mozzarella and bread, and enjoy that for lunch just about every day of the week.

Summer is also when the chickens take advantage of the long daylight hours and ramp up their egg production. More sunlight equals more eggs. It is also when the chickens will take long, glorious dust baths, digging ditches in the ground and covering themselves with dirt only to shake it off in a brown cloud at the end of bath time.

We are up early to take advantage of the cooler mornings. While summer mornings are all about getting things done, observing the changes on the property, and making improvements, summer nights are for stargazing. The rhythm changes, but that's amazing because each season has its own challenges and charms.

A Windowsill Herb Garden

The most basic homesteader project you can absolutely, 100 percent accomplish is starting your own herb garden. I promise, you can do this.

I keep an impressive array of dried herbs on hand, but the longer we live up here on the mountain, and the more our gardening skills improve, the less often we use those dried herbs. Instead, we head straight to the kitchen window to get all the flavor we need.

And we need a lot of flavor. Since we don't go out to eat nearly as often as we did living in the city, it's important that we really enjoy our meals here on the homestead. Our lives up here, and our different choices, aren't better or worse than anyone else's. They are simply different. But having fresh herbs on hand? Definitely puts a mark in the "better" category.

You can start an herb garden from seed, but if this is your first time and you just want herbs right now, head over to the garden store. For the price of a dried bottle of crunchy flavor, you can purchase a fresh, replenishing plant that keeps giving you flavor for a year or more.

If this is your first foray into gardening, let me tell you that I am the woman who has always had a black thumb. I tried large-scale gardening projects but rarely had success. If I can grow a windowsill herb garden, you can too.

Here are some of my favorite almost-foolproof herbs to grow:

Basil: Caprese salad is one of our most favorite dishes to make in the summer because it is 100 percent made on the mountain. We bake the bread, grow the tomatoes, make the cheese, grow the basil, and buy the oil and vinegar from a farmer up here in our postage-stamp-size town. It doesn't get much more "farm to table" than that. (And it's super impressive to show visiting friends all the places their meal came from.)

Peppermint: This may be a close rival to basil as the easiest herb to grow. If you are looking for a homesteading confidence booster, grow some peppermint. It is foolproof, even for new homesteaders. I love to clip the peppermint leaves to put in our iced tea. You can also infuse peppermint into a simple syrup to add to your tea or coffee.

Chives: A baked potato's best friend. We use chives in our sauces, eggs, soups, and dips. Chive plants are so easy, they almost grows themselves. We have some in our greenhouse that we ignored after a big winter storm, but they just kept doing their job and produced chives all through the spring and summer.

Rosemary: I love this herb. I use it constantly in chicken dishes, and there is nothing better than roasted and smashed potatoes with some rosemary. This grows like crazy in our garden and on our porch.

Cilantro: Roger makes his own salsa, and cilantro is a key part of his recipe. He will make as much salsa as possible based on our tomato and pepper production, and I try to keep him well stocked with cilantro.

There's no law that says you can't grow more than one of each herb in your windowsill. I love basil the most. It is my favorite herb to put in almost any dinner meal, so I have two plants in the kitchen, one on the porch, one in our greenhouse, and one in our garden. That way, if any of the mountain critters (or my cat) get any funny ideas, I have plenty of other sources.

Do Things That Actually Make a Difference

Homesteading can make you feel inadequate. There are 742 priorities, and if you watch TikTok videos or read articles about homesteading, you will discover that all of them have to be done *immediately*.

Overwhelmed much?

Take a deep breath—you've got this! And to help you prioritize, here is my recommended order of things to do on a homestead.

Do the things that . . .

1. . . . will keep you alive. Chopping wood is more important than touching up paint on a chicken coop.

2. . . . will pay off in the long run. It takes less time to water our garden than to lay out a watering system, but over time, that watering system will save us thirty-five minutes every other evening during much of the spring, summer, and fall.

3. . . . are low-hanging fruit. An herb garden? Low-hanging fruit. It's cheap, relatively easy, and accessible, and it takes up very little space.

4. . . . are fun. Yes, you have to do the important stuff (staying alive) and the investment stuff (things that will pay off in the long run), but it's also important to do the fun stuff. Is painting rocks to use as markers in the garden necessary? No. Is it life-giving? To me it is.

There's also a whole other category of homesteading activities you

can ignore—the tasks that don't fit into your overall homesteading plan. For example, we love our chickens, but they're not a crucial homesteading element. If you don't like eggs or don't feel like chickens would add to your overall happiness, you do not have to raise them.

If your house has central heating, you are under no obligation to chop wood. (But if you have a fireplace and the power goes out, you'll be really glad you have pyramids of covered firewood, just in case.)

If you hate gardening, buy your fruits and vegetables at the local farmer's market.

Do the things that are necessary and life-giving. And are a whole lotta fun for you. (Even if it's weird, homestead-y fun.)

Pulled Pork

One of my favorite parts of living the homesteader lifestyle (or at least the trying-to-homestead lifestyle) is eating in tune with the seasons which is pretty easy to do in the summer. But eating in tune with the seasons in, say, early spring, when you're just learning how to grow stuff in this fickle climate, will bring on a case of scurvy. Nothing but your indoor herb garden will produce anything edible, and while working in the snow and rain, you want something a little heartier than a basil salad.

One of my favorite meal staples that can be made almost entirely from ingredients in the freezer and pantry is pulled pork, which can be used for tacos, nachos, quesadillas, and more.

Ingredients

1 T. vegetable oil
1 (4 lb.) pork shoulder roast
1 ½ cups barbeque sauce
½ cup apple cider vinegar
½ cup chicken broth
¼ cup light brown sugar
1 T. yellow mustard

1 T. Worcestershire sauce
1 T. chili powder
½ tsp. cinnamon
1 large onion, chopped
2 cloves garlic, crushed
1 ½ teaspoons dried thyme

Directions

1. Spread a thin layer of vegetable oil in the bottom of your slow cooker, set in the defrosted-in-the-fridge pork roast, then pour and sprinkle all other ingredients, in order, atop the roast. Cover and cook until the roast shreds easily with a fork, about 5 to 6 hours on high or 10 to 12 hours on low.

2. Remove the roast from the slow cooker and shred the meat using two forks. (I've also used a hand mixer to shred the pork.) Return the shredded pork to the slow cooker, and use a wooden spoon to mix the meat into the juices.

This recipe makes a ton, but I sometimes make it even when it's just Roger and me so I can freeze the leftovers for homestead fast food. If you love a good pulled pork sandwich, I highly suggest these leftovers with a hamburger bun, a little coleslaw, and some dill pickle slices. It may be my favorite sandwich of all time.

12 servings

Kathi's Quick Queso

This is a recipe I found on the internet and tweaked until I got it just right. My friend Susy requests this whenever she comes over for dinner. (She lives with people who are all lactose intolerant, so she is very cheese-deprived.)

It is perfect just with chips, or you can pour this golden goodness over a taco, nachos, veggies—anything will be improved by this queso.

The only problem with this dip? It is addictive. About once a year, Roger will request it when we're not having a party or having anyone over. I have to section it out in different containers so we don't eat ourselves into a coma.

You will need aluminum foil, a whisk, an Instant Pot, an Instant Pot trivet, and a bowl that is safe to use in the Instant Pot (I've always used a plain glass bowl, but Pyrex would be great too).

Ingredients

1 cup water

¾ lb. American cheese (I just use about ¾ of a package of Kraft American cheese)

1 cup shredded cheese (I use a Mexican blend)

1 T. butter

8 oz. cream cheese, softened

1 T. minced garlic (I like to use the frozen squares of garlic by Dorot)

1 cup salsa or 1 small can Rotel diced tomatoes and green chilies (found in the Hispanic or international food aisle)

1 T. milk

1 T. dried oregano

Directions

1. Add the water to your Instant Pot.

2. Put the trivet in the bottom of your Instant Pot.

3. Add all ingredients to your Instant Pot–safe bowl and wrap the whole bowl, top and bottom, with foil.

4. Place the lid on the Instant Pot, make sure the valve is sealed, and set the machine for 18 minutes on manual high pressure.

5. After the timer goes off, release the pressure immediately.

6. Remove the lid once all pressure has been released.

7. Remove the aluminum foil and whisk the dip until smooth.

 12 servings

One for Now, One for Later

I've always loved a good LOOP (Left Overs On Purpose) recipe—cook once, eat twice (or three times). I rarely make a meal that will feed us only once. When I make bread, I bake one loaf to eat right away and one to put in the freezer for the week I don't have time to bake bread, because making two loaves of bread takes only a fraction more time than baking one loaf.

When I make muffins, I make a double batch so we can have some for the weekend, some to give to our neighbors, and some to put in the freezer.

But that principle is not only for making delicious leftovers. When we buy chicken feed, I buy one for the bucket (stored outdoors, near the chicken coop) and another one for the barrel (stored out in the barn). No sense going to the feed store every other week when we could go once a month.

Instead of picking out my clothes on Sunday for Monday, I pick out my clothes for the entire week.

I take a prescription every day. So does Roger. We've asked our doctors for a ninety-day supply, rather than a thirty-day supply, so we have our pills for the next several months.

I believe in this planning principle so strongly because there may come a time when you need to have things as convenient as possible. During seasons when there is more to do on the homestead than there are hours in the day, not having to cook a meal from scratch or run into town to grab a prescription or chicken feed is just the win a tired homesteader needs. In the event of an emergency, it's nice to have some food pre-made. For example, during a snowstorm power outage, you can't bake muffins, but if you've made extras, you have plenty to thaw out and enjoy.

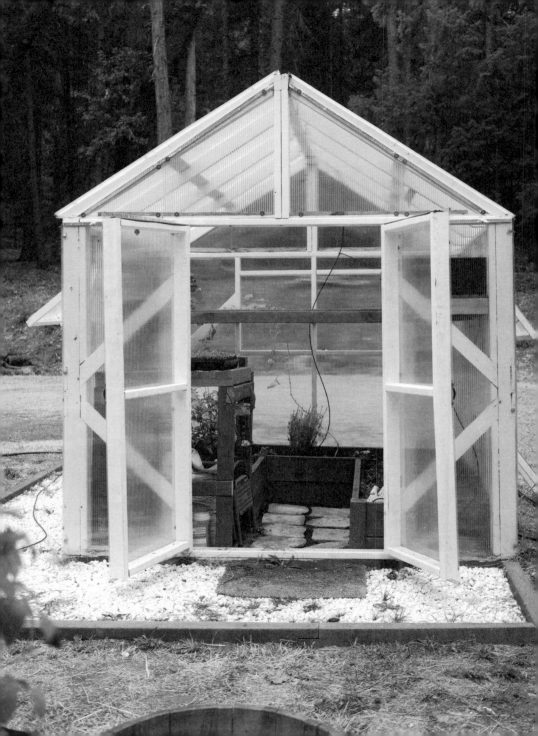

Home Projects and Why You Should Double the Timeline

(and Let's Be Honest, the Budget)

When we first bought the Red House, I looked at designer magazines, trying to dial in on the kind of vibe I wanted to create.

Every homesteader (accidental or otherwise) on Instagram or Pinterest or in the magazines had an all-white interior.

All white. For a homestead.

Have mercy.

There are many words I would not use to describe a homestead. Pristine would be at the top of that list.

I didn't want our living room to be someplace we had to ask people to remove their shoes before they sat down. We needed couches that could be wiped off, floors that could be scrubbed. When one of the ladies needed to recover from an illness or an injury, we needed a place to put the chicken cage without worrying about the lasting effects on our carpet.

White? Is not a homestead-y option.

Because we received two black leather couches as hand-me-downs, we styled our living room in black and cream with touches of red. But I wanted a bit more fun and color in the kitchen. We already had a blue couch from our house in San Jose. (Yes, we have a couch in the kitchen. It is where everyone ends up hanging out to talk while we're making dinner.) So we decided to do blues with touches of red in the kitchen.

Every big decorating, gardening, construction, and remodeling project up here has followed the same pattern.

Start.

Stop.

Start.

Stop. Stop. Stop.

But the results? Better than any decorating magazine could have shown. Better than I could have hoped for.

Here is my best advice for decorating and home projects on your homestead, especially if your nearest home improvement store is not just around the corner.

- *Break down your project into smaller chunks.* Planting a 16 x 32-foot garden and enclosing it with a fence is an overwhelming project. But researching the kind of design you want for that fence is immensely doable. Take your projects one bite at a time to keep from getting overwhelmed.

- *Keep good lists.* There is nothing more frustrating than arriving home from running all of your errands in town, only to realize you forgot that one tool you need in order to move on to the next phase of your project. (And then having a marriage-enhancing discussion with your spouse about whether it's worth it to go back into town to get it.)

- *Double (quadruple?) your time estimates.* There are a lot of chores to do on even the simplest of homesteads, so most decorating projects are completed in small chunks of time. It's more important to take care of the hardware mesh on the chicken coop than it is to paint the small bedroom. A decorating job that would take you a weekend in the suburbs? Plan on a month on the homestead.

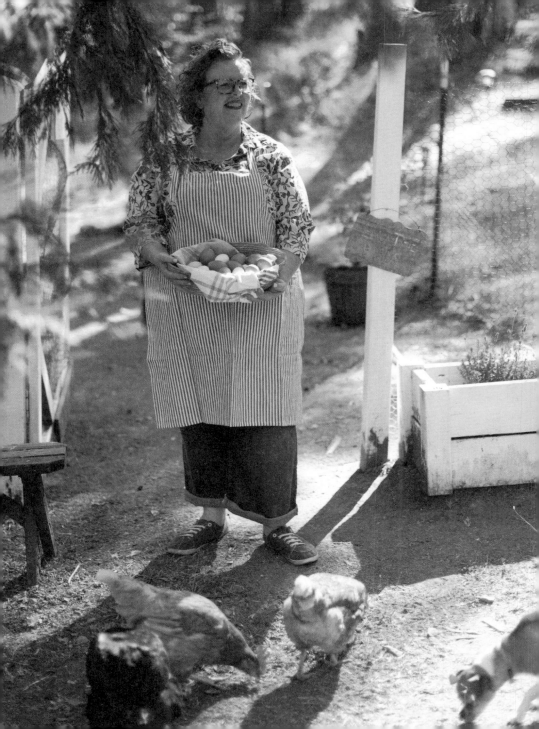

Living with the Seasons

When we lived in Silicon Valley, all I had to do to prepare for the changing seasons was either put an umbrella in my car or take an umbrella out of my car. The Bay Area is famously known for its mild temperatures, so weather was never really a "thing" for us.

That all changed when we moved to the mountain.

Now we are tied to our weather apps to plan out our week. What day will it be too hot to go outdoors? Is there snow in the forecast? Do I have to water tonight, or will it rain tomorrow?

Why, just this morning, I had planned to refresh the chicken coop (clean it out, refill the chicken food, put new pine shavings in the nesting boxes, and shovel out the run), but we got a surprise midsummer gully washer (which is an answer to prayer, as it's fire season). And since the chicken coop is filled with sand (and chickens will let you know that they do not like wet sand), they will be getting their coop cleaned out tomorrow instead.

Before and after our day jobs, we have about an hour in the morning and three hours in the evening to work on the house and property, and we need to do some chores regardless of the weather—things like dishes, cooking, cleaning, laundry, feeding and watering the chickens, and checking on the greenhouse.

But as we turn over the seasons, we also turn over our schedules.

Since we don't have air conditioning here at the house, we spend an awful lot of time making sure we don't heat up the place in the summer.

Staying Cool in the Summer

Here are a few of the ways we avoid heating up the house in the summertime:

- We line dry our clothes, either outside on a laundry line or a drying rack, or inside with hangers on the shower rod. If we want to use the dryer for big things like sheets or bedspreads, we run it overnight and not during the hottest part of the day.
- We run our slow cooker in the patio room where we can shut the door and trap the heat.
- When we need to bake, we use a toaster oven instead of the full oven. (On the hottest days, I've been known to run the toaster oven outside.)
- We plan meals that don't need to be heated up. (We eat a lot of salads and sandwiches in the summer.)
- We grill outdoors. (Double bonus: Roger loves to barbecue, so I get a night off from cooking.)
- We cook everything on Saturday so we heat up the kitchen just once a week.
- We move my workstation downstairs in the afternoon, where it is about twelve degrees cooler than it is upstairs.
- We do outdoor tasks in the morning, when it's the coolest.

Staying Warm in the Winter

During the winter, we have the same kind of list, just in reverse:

- We use our dryer (and let Moose jump into the warm pile of clothes).

- We run our slow cooker all day, inside.

- We leave the oven door open after baking to help warm the house.

- We prepare every meal in the oven, in the slow cooker, or on the stove top so we can enjoy that extra heat.

- We cook meals in the winter and then freeze them for spring, when we can warm them up in the microwave.

- We chop wood all spring, summer, and fall so we are good to go for the winter.

- We keep extra fleece-lined blankets in every room of the house.

- We wear our favorite bulky sweatshirts from morning until bedtime.

- We top every bed with an electric blanket.

- We use a cast-iron teakettle on the wood-burning stove, not only to heat the living room but also to keep us from drying out.

There are dozens of ways to either heat up or cool down your house, depending on which way you want the thermometer to go. Oh, and for the hottest and coldest nights of the year, we have "room" heaters and air conditioners so that we're cooling or heating just the room we're in (and closing the doors to the rest of the rooms).

Please Don't You Be My Neighbor

\mathcal{E} very Saturday, I cook. Cooking is my favorite thing to do.

Okay, it wasn't always my favorite thing when we had four kids at home who needed to be fed. Every. Single. Night.

But now that the kids are grown and we are living here on the mountain, there is nothing I love more than finding or creating a recipe, shopping for or growing the best ingredients, and spending a part of my Saturday listening to weird podcasts while chopping, sautéing, roasting, and mixing food to put on the table.

The only problem is that I cook for six even though it's just me and my husband.

So every Saturday, I take a big cooler of food to our neighbors Paul and Julie. Paul and Julie are our local firefighters and part of the reason our house is still standing.

In 2021, on a Saturday in August, Roger and I heard multiple helicopters flying over our house. We've learned that helicopters mean one of two things: (1) Our local power company is checking the lines to see if any have fallen and could cause a fire, or (2) there is already a fire in the area.

I checked our local Facebook page to see if anyone knew the story. There were rumors of a fire not too far from our home. Roger rode up to the top of our mountain on our ATV and ran into a firefighter who gave

him more information. He explained that there was a grass fire about a mile and a half down in the forest. Roger asked him if he thought we should evacuate.

He said, "I can't say officially, but if it were my family, I would evacuate."

That was all Roger needed to hear.

We made a plan: Roger would take the chickens to our friend Susy's house. I would grab our most important papers, Moose, and Ashley, and then head to my mom's, where Roger would meet us after the chicken drop-off.

Roger didn't get to my mom's house until midnight. We prayed and then fell into a deep sleep for a few hours before checking on social media to see what was happening.

That's when we realized the wind was shifting and was heading not just toward our house but also toward Susy's. We had to go get our chickens.

Susy packed them up, along with her own two dozen chickens and their rooster, Sheldon, and met us in a grocery store parking lot. We hugged, loaded the chickens, shared a box of donuts, and then headed back to Mom's to wait out the evacuation and see if our house was still standing.

Every day, multiple times a day, we checked the NASA fire maps to see how close the fire was to our house and our neighbors' homes. There were times when we were sure the house was engulfed in flames. On a particularly low day, when we didn't know if our house was still standing, we saw that Grizzly Flats, part of our town, had lost hundreds of buildings overnight. I got a call from an unknown number.

"Hey, Kathi, it's your neighbor Paul. I just wanted you to know that as of this morning, your house is still standing."

I almost passed out from relief. This house that we had prayed for, that we had worked on, that had sheltered us and others during times of crisis, was still standing.

Paul, Julie, and other volunteer and career firefighters had done the backbreaking work of cutting a fire line to protect our group of houses.

These heroes spent three weeks with little sleep, battling to save not only our beautiful forest but also our homes.

I get a little teary every time I think of it. I am now the woman who breaks down every time I see a firefighter in a grocery store, because every fire department in this area was either fighting the Caldor Fire or holding down the fort while others were out.

And because I'm used to feeding a crew instead of a couple, I'm so glad I get to share some of the food I make with some of the people who saved our mountain. It is my tiny offering to the people I cherish.

So on Saturdays, I cook up a big pot of chicken and rice soup or make a feast of gyros and place all the ingredients into their own little containers. I pack everything up into an insulated freezer bag and hang it on Paul and Julie's front door, so when they get home from a day of clearing brush or going on a medical call (because those are just some of the things a volunteer firefighter does on a Saturday), they will have a meal ready to heat up and eat.

Know Your Neighbors

When you decide to become (or accidentally become) mini-homesteaders, you are sent back to kindergarten in so many ways. Roger and I are considered experts in our respective fields, but we came to the mountain as absolute homesteading beginners. Besides books, YouTube, and Facebook forums, our best source of knowledge and help has been the people who live closest to us—our neighbors.

When we first got here, our neighbors were wary of us. We were new to the community, renting our house as an Airbnb, and holding writers' retreats with people coming from all over the world. Let's be clear—we didn't know what we were doing. No one was too thrilled to call us *neighbor*. (In fact, many of the people up here on the mountain are still pretty wary of us.)

There was a lot of open hostility in the beginning. But as our neighbors saw that we were not okay with all-night raves, were serious about fire safety with our guests, and wanted to contribute to the community, the people who lived near us started to warm up.

We have Paul and Julie, our firefighting neighbors. Our next-door neighbors Patrick and Nancy keep us informed of all the goings-on around here. And we have another team of huge helpers, like our friends Susy and Robert, their daughter Teddy, and her boyfriend, Forrest.

Susy is my go-to friend here on the mountain. When we're sick, she brings us soup. When there is something to celebrate, we are at each other's

houses. She teaches at writers' retreats here at the Red House. When it's time to cut wood, Robert shows up and helps Roger with all the logs so that each of our houses can be ready for winter.

Forrest and Teddy are our nature experts. It's as if they are woodland creatures come to life in human form. I've called Teddy more times than I can count to get chicken advice, consult about an injured animal on our property, and more. Teddy is an animal savant; she runs a squirrel rescue in a barn on their property. And Forrest, besides raising baby chicks for us, is our garden expert. He's helped us plant trees, shared his secret plant additive for the soil, and consulted with us about what will grow on our mountain.

When you are on your own homesteading adventure, may I suggest that you be the first one to show up at your neighbor's houses with cookies (homemade or store-bought—the decision is yours).

If you need a great cookie recipe that will feed the entire neighborhood, here is the one that my kids beg me to make whenever they come to visit. It will bring your new neighbor's wariness level down by 12 percent. (I've also included instructions to freeze the dough so you can make cookies when a neighbor drops by unexpectedly, because that's something that happens in the country.)

The World's Best Chocolate Chip Cookies

(Recipe may be halved.)

Ingredients

2 cups butter

2 cups granulated sugar

2 cups brown sugar

4 eggs

2 tsp. vanilla

5 cups oatmeal, blended to a fine powder (this is what keeps these cookies so dang moist!)

4 cups flour

2 tsp. baking soda

2 tsp. baking powder

1 tsp. salt

24 oz. chocolate chips (I like milk chocolate, but semi-sweet, dark, or white chocolate chips work well too)

8 oz. chocolate chips, blended into tiny chunks in the blender

3 cups chopped nuts (your choice)

Directions

1. Preheat the oven to 375°.

2. Cream the butter and both sugars. Add the eggs and vanilla, then mix in the oatmeal, flour, baking soda, baking powder, and salt. Stir in the chocolate chips, ground-up chocolate chips, and nuts.

3. Place small mounds of dough on cookie sheets lined with parchment paper, working in batches. Bake each batch for 10 minutes, then remove the cookies to a cooling rack while you bake more and more cookies.

Makes 112 cookies

Hint: These can be frozen into pre-scooped balls or ready-to-slice logs. Just flash freeze scooped balls on a cookie sheet before packaging. It will make them easier to handle, and they'll keep their shape better if you are freezing a lot of packages on top of each other.

For logs, wrap the dough in plastic wrap and form a log about 2" in diameter.

I package my dough in large Ziploc bags. I put the dough in the bag and write baking instructions right on the bag. I like to experiment with the cookies and discover the best baking time and temperature for frozen dough versus thawed dough. My favorite method is to bake thawed cookies for 10 minutes, and then keep checking every 2 minutes to get them just perfect.

Tomato Soup

The vegetable that grows best on the mountain is tomatoes. They are almost black-thumb tolerant, and it makes you feel like a real gardener when you actually eat something you've grown from seed.

Of course, the first thing I think about with tomatoes is how I'm going to eat them in a salad. Of all the things that taste better when you grow them yourselves, tomatoes are at the top of the list. In the spring, when all my tomatoes come straight from Costco, I think there can't be that much difference between tomatoes from the store and tomatoes from the garden. But then we pick that first tomato of the season, splitting it between the two of us because it's such a momentous occasion. During the rest of the meal, we discuss the idea of growing hydroponic tomatoes in our sunroom, because we are desperate to have tomatoes that taste just like this all year long.

But the double-edged sword of tomatoes is that they are best for a season. So we make tomato salads while the sun shines, using tomatoes in everything from our breakfast scrambles to our late-night Caprese salad, which is eaten around the fire with a glass of wine, and all is right in our tomato-y world for those three wonderful months. Another way I love to use a bounty of tomatoes? Tomato soup.

Every Saturday, I pull out my Lodge Dutch oven, make soup, and let

it cool. Then I put the whole pot in the fridge. On Sabbath, all I have to do is put that pot back on the stove to heat up dinner. So obviously, I'm always on the prowl for soup inspiration.

When I was in Arizona, I went with my friends Jennine and Michelle to the White Chocolate Grill and devoured their Tomato Gin Soup. (I also somehow talked the whole table into getting it, but nobody regrets my strong-arming them into buying the soup.)

Here is my version of the soup, which I just made, tasted, and declared as good as (if not even a little bit better than) the one at the restaurant. (But that is only because they didn't have fresh chives on theirs.)

My only recommendation? Double the recipe. You will want to have this with a grilled cheese sandwich for lunch later in the week. Promise.

Tomato Gin Soup

Ingredients

10 to 12 fresh tomatoes, peeled, or 1 (28 oz.) can whole peeled tomatoes

3 garlic cloves, chopped

1 tsp. thyme

½ tsp. paprika

1 tsp. sugar

6 slices bacon, chopped

¼ cup salted butter

4 oz. brown mushrooms, sliced

1 cup gin

½ cup heavy cream

Salt and pepper

2 tsp. chives, diced

Directions

1. Combine the tomatoes, garlic, thyme, paprika, and sugar in a blender and puree into a liquid.

2. In a heavy soup pot or Dutch oven, sauté the bacon until crisp; drain on paper towels but leave the drippings in the pot.

3. Melt the butter in the pan with the bacon drippings, then add the mushrooms and sauté until golden.

4. Add the gin, return the cooked bacon to the pot, and stir in the tomato sauce. Simmer for 15 minutes.

5. Add the cream, season with salt and pepper to taste, and top with chives.

 4 servings

Serve as an appetizer or alongside a hearty salad with crusty bread.

Don't Give Up What You Love. Adjust!

When we first moved to the mountain, I would find any excuse to go into town. While we were there, we'd go out to eat, do a little shopping, and of course, get a Starbucks.

Now that we've settled into our homestead, we are good with going to our big city just once a week. It's fun to eat something I'm not great at cooking.

But one of the reasons we can wait a week is that we've learned to create some of our favorites at home.

Last year, instead of giving each other gifts for our birthdays, Mother's and Father's Day, and our anniversary (which all come within a month of each other), Roger and I "gave" each other an espresso maker. Roger has learned the art of fancy drink making, and now a latte is never more than a "Hey, honey . . ." away.

I've learned how to copy some of our restaurant favorites, including jambalaya, all kinds of soup, fancy salads, and pasta dishes.

I've also found great substitutes for the things we used to go out for. Roger loves the vanilla scones from Starbucks. I found a copycat recipe and started making them at home, only to discover that Trader Joe's makes an awesome vanilla scone. They come in a package of four, and it's the perfect amount for a small treat for him.

Sometimes, homesteading can make you feel like you are giving up a lot of what you love. But with a little creativity, you can often have what you love, just in a different way.

❋ FALL ❋

Fall has always been my favorite time of the year, but I didn't know what fall was really like until we lived on the mountain. Fall has so many gifts.

The vineyards all around our house are loud with color. The golds, greens, yellows, oranges, and purples are downright riotous. Driving home, which is always a pleasure, is a visual symphony in the fall.

There is work to be done, but it is so much more pleasant in the fall than any other time of year. Not a lot of rain, the temperatures are almost perfect, mosquitos have stopped their invasion for the year, and the work is "fun" work: picking vegetables, gathering apples, baking bread ahead for the winter, doubling up on soup production. Yes, there is also getting the house ready for winter, but even that is done while the sun is still shining and you're not having to wade through snow in thigh-high boots (and we're not talking the ones found on the streets of Paris—we're talking the ones found on the aisles of Tractor Supply).

Fall is perfect "sitting around the fire" weather. We can finally start lighting our inside woodstove that Roger has been chopping wood for since spring.

In fall, every room gets "cozified." We pull out heaters and extra blankets. Candles pop up everywhere. It's what you imagine living in a mountain home feels like.

Feeding
the Farmhands

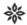

Once we'd been living here for almost a year, I began to feel like we were finally giving in to the rhythms of the house.

Part of the reason we bought the house was to have writers' retreats. My friend, mountain mentor, and *New York Times* bestselling author Susy Flory lives nearby (it's just a thirty-minute drive, which in the mountains makes you practically next-door neighbors). We love to gather writers together, learn together, and most importantly, eat together.

When you have that many people gathered together with so many eating requirements, you can't just make a casserole and call it a day. And by the way, I'm not hating on casseroles. I make a chicken poppyseed casserole that my friend Vickie's mom created, and (have mercy!) my son asks for it every time he comes to visit.

But I have found the solution to cooking for a diverse array of diets, and that is the bar system.

The bar system for meals means that your guests can choose what they'd like to have without mixing every ingredient together.

With the bar system, you can have options for a salad, a bowl, or a wrap. Here are a few suggestions for "bars" you could try. Please do not look at these as a list of requirements—just a springboard to solve your own crowd-feeding dilemmas. Each option has ideas for a base (first layer of food, usually a grain or veggie of some kind), a substance (usually a

protein like meat, beans, or both if you have low-carb eaters and vege-
tarians in your group), a flavor (like cheese or veggies), and a dressing to
make it really sing.

Taco Bar

The base: chips, tortillas, rice, or lettuce

The substance: grilled tofu or TVP (textured vegetable protein) for your
vegetarian or vegan friends, plus chicken, pulled pork, or ground beef
cooked with taco seasoning

The flavor: cheese and grilled or sautéed veggies

The dressing: salsas, salad dressings, pestos, crema, sour cream, guacamole,
and lime or lemon

Potato Bar

The base: potatoes, of course! I usually bake a bunch of russet potatoes in
a slow cooker, but you could also do a smaller variety, like a smashed
golden potato.

The substance: shredded cooked chicken, chili, broccoli, and black beans

The flavor: shredded cheese, queso, sautéed onions, green peppers, mush-
rooms, chopped chives, diced green onions, and chopped cooked
bacon

The dressing: salsas, salad dressings, sour cream, and butter

Oatmeal and Yogurt Bar

The base: oatmeal and yogurt

The substance: chopped berries and other fruit

The flavor: shredded coconut, almonds, pecans, or granola

The dressing: honey, maple syrup, fruit syrup, or brown sugar

Salad Bar

Serve with a favorite soup, or add a tortilla, flatbread, or pita for people to make wraps.

The base: lettuce—think of other lettuces besides iceberg, including romaine, baby spinach, arugula, or a bag of mixed lettuce.

The substance: chopped cooked chicken, ham, bacon, tofu, or hard-boiled eggs

The flavor: any veggie you can think of, like red onions, avocados, chopped tomatoes, shredded carrots, beets, and cucumbers. Add crumbled or shredded cheese, dried cranberries, chickpeas, fresh strawberries or blueberries, nuts, and croutons.

The dressing: oil and vinegar, ranch, Italian, honey mustard—whatever complements your other ingredients well

Charcuterie Board

The base: crackers, pita bread, pretzels, slices of cucumber (Be sure to offer and label gluten-free items for those with sensitivities or allergies.)

The substance: hard cheeses, like cheddar, Swiss, and smoked gouda; soft cheeses, like goat, brie, crema, and Havarti; cured meats, like ham, sausage, salami, prosciutto, and pepperoni; hard-boiled eggs

The flavor: nuts, pickles, olives, sliced apples, and cocktail onions

The dressing: spreadable cheeses, dips, tapenades, and jams; strawberries, grapes, dried apricots, and dark chocolates

Dessert Bar

The base: ice cream (add cones for extra fun), frozen yogurt, gelato, cake, cupcakes, cookies, donuts, or brownies

The substance: fruit—I love any kind of berry, or some sliced peaches cooked down with a little bit of water and sugar

The flavor: marshmallows, frosting, crème brûlée, nuts, and candies

The dressing: chocolate syrup, macerated strawberries, whipped cream, cookie crumbs, and sprinkles

If you are feeding a crowd for a few days in a row, I highly recommend getting some serving bowls that come with lids. I ordered some 24-ounce bowls that have airtight lids from Amazon. When we've had a writers' retreat and want to have bowls of chopped mushrooms, onions, peppers, berries, and so on at each meal, but don't want to go through the hassle of putting everything into storage containers, transferring them into serving bowls, and then putting them back into storage containers, we just use these cute lidded bowls. We can do the prep of washing and chopping the day everyone arrives and then store them in the refrigerator. When it's time for the first meal, we bring everything out and then replenish as necessary. Less stress for the cook, the grocery put-away-er, and the dishwasher.

Planning and Shopping

When I lived in the 'burbs, it was absolutely no problem to run back to the store for a forgotten ingredient. Now there is nothing that will compel me to go to the store unless I've forgotten lifesaving medication (or once a year, when I just really want a Jamba Juice). So I am meticulous about planning our meals and the grocery list.

I bring out the Cuisinart and do as much batch chopping as I can for the week. For example, chopped onions keep well for the entire week, but they tend to smell up the fridge. Solution? I chop a ton of onions and stick some in the freezer to be used later in the week.

When I have guests, I make sure that—as much as possible—the washing, chopping, and other prep work is done before everyone starts arriving. I want to be a charming host, and I do not effortlessly exude charm when I'm panicked.

Planning for Food Intolerances and Allergies

Technically, we could sleep sixteen very friendly people here for our retreats. However, that is not a theory we want to test since we currently have only one shower.

Instead, when we have retreats, we limit it to Roger and me, six writ-

ers, one "writer-in-residence" (someone who teaches with Roger and me), and a house elf (a writer who gets to attend for free in exchange for being the main point person for cooking and keeping the kitchen and bathrooms tidy).

Even with just ten people in attendance, feeding that many bodies can be a challenge.

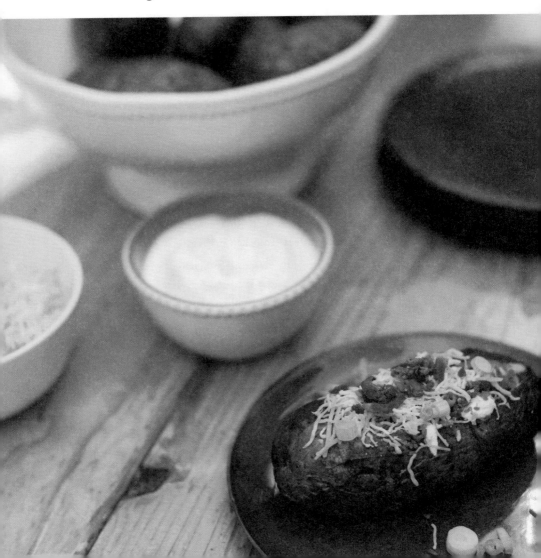

Since many of those attending have different food intolerances and allergies, we must be extra creative with what we serve.

A couple of pro tips for feeding a lot of people when you live far from civilization:

1. Ask for a list of allergies or intolerances ahead of time. Sometimes, you could have someone who is gluten-free, someone who is vegetarian, and someone who is lactose intolerant all at the same time. Having a list ahead of time will help you plan and find recipes that will work for everyone.

2. Ask for details about specific foods your guests can and cannot eat. It took me way too long to find out that some people who are lactose intolerant can eat things like cheese and ice cream but not milk. Find out dietary specifics so you know how to plan.

3. Find out how they take their coffee. People are very particular about what they have in their coffee. I like to ask everyone since we often have some people who like heavy cream, some who drink oat milk, and some who do better with coconut milk. And then there's that one guest who can't live without her nonfat milk frothed. (Okay, I admit it. That last one is me.)

4. Tell guests in advance, "Bring or buy what will make you comfortable." We used to ask people to tell us what food would make them most comfortable while they visited us. And then I didn't get the memo that someone needed cashew butter, so I didn't buy it. It wasn't pretty.

So now we ask people who are driving here to bring what will make them comfortable. If they are flying in, we take them from the airport to a great grocery store with lots of vegan, vegetarian, gluten-free, and lactose-free options. If someone has a particularly acute allergy, we will work with them in advance to make sure they are safe and comfortable. That way, everyone has what they need

to be happy while they are here and a good hour away from a real supermarket.

5. Create a recipe file. When you find a recipe that fits a couple of categories (gluten-free and vegetarian!), keep that recipe. Make sure it's in a place where you can easily find it for your next large gathering.

6. Make it work. A few months ago, we had a large group here for a retreat where half the people were gluten-free, so I found a breakfast casserole recipe that used hashbrowns instead of bread. After some tweaks, I made it my own and served it with fruit. It was a huge hit.

HOMESTEADING PRINCIPLE
Make It Multipurpose

We rarely have an ingredient on hand that can be used only one way.

On Monday, we will have oatmeal with strawberries, blueberries, and peaches. On Tuesday, we will have those strawberries and blueberries in a salad, and the peaches grilled on top of a pork chop for dinner. Finally, on Wednesday, those fruits will get chopped up and put on top of frozen yogurt for dessert.

Leftover oatmeal will be turned into baked oatmeal. Leftover chicken will go into a soup. Stale bread will be turned into a frittata. For everything you buy, grow, or are given, find a second (or fifth) use.

Hashbrown, Egg, and Sausage Casserole

Ingredients

1 lb. pork breakfast sausage

½ cup onion, diced

2 cups (10 oz.) frozen hashbrowns, defrosted

2 cups spinach, finely chopped

10 eggs

1 tsp. salt

½ tsp. pepper

½ tsp. oregano

½ cup milk

1 cup shredded cheddar cheese, plus a little more for the top

Directions

1. Preheat the oven to 350°. Lightly grease a 9 x 13-inch baking dish.

2. Heat a large skillet over medium-high heat. Add the sausage and onion. Break up the sausage, cooking until the onions have softened and the sausage is no longer pink. Drain any excess grease.

3. Add the spinach and heat until it is wilted. Remove the skillet from heat and let it cool slightly.

4. Combine the remaining ingredients in a large bowl. Add the sausage mixture and stir until combined. Pour the mixture into the prepared baking dish. Top with extra cheese, about ¼ cup.

5. Bake the casserole for 25 to 30 minutes, uncovered, until the eggs are set. Let it cool for 5 minutes, then serve.

8 Servings

This recipe can be adapted to your group's particular food preferences. For example, at one of our retreats, one of our guests was gluten-free, and another guest was a vegetarian. I made a simple swap by pulling out the sausage and using soy chorizo instead. I've found that when adjusting a recipe—except for baking—you can almost always safely substitute or leave out one ingredient without affecting the flavor too much.

It's fine to sub the soy chorizo for the sausage, or a cheese substitute for the grated cheese, but I wouldn't try both the first time I was making this recipe.

We also have an "open pantry" policy. Anyone can help themselves to anything in the pantry, fridge, or freezer. I will let people know ahead of time if I'm saving any snackable food for a recipe. (Baby carrots? Snackable. Barley? Not snackable.) Or I just put it in the outside fridge so it doesn't accidentally get eaten.

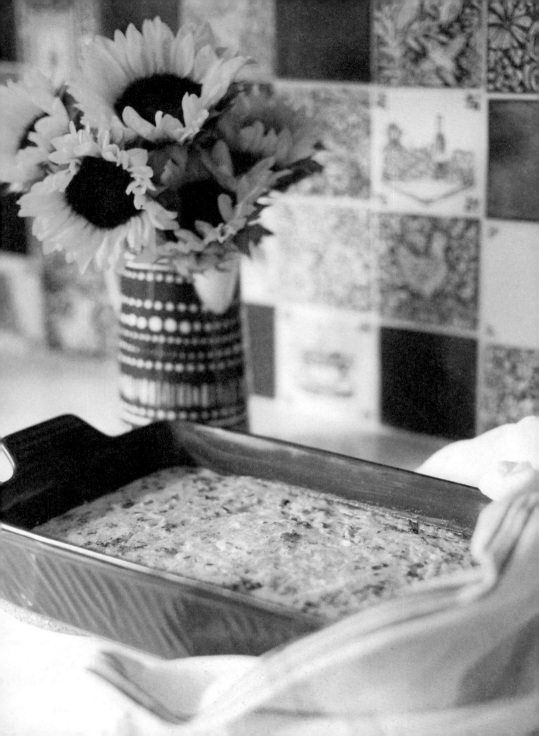

Apple Cake

One of the things you will notice when trying to live off your land as much as possible is that what you eat changes dramatically.

When you have chickens, you'll start to seek out every recipe that will help you use up eggs. A breakfast casserole that uses up a dozen eggs? Bring. It. On.

Any recipe with berries, tomatoes, squash, and eggplant is on my list. I hoard those recipes that use up what we grow on the homestead like I used to hoard Nordstrom shoes.

We are still trying to crack the code for getting fruit trees to prosper on our property, so I've limited our recipes to the fruits I'm willing to buy at Costco.

That is, until my friend and neighbor introduced me to a "gray area" of homesteading—apple picking on abandoned properties.

We've foraged for blackberries along our shared road before, but it felt scandalous to pick apples on properties where I didn't know the owner.

There are a bunch of properties near Susy's house that are just abandoned orchards right on the main road. The land has no value except to people who are looking for "found fruit." So one fine fall day we met Susy at an orchard with some gloves and a couple of buckets.

Susy, the more seasoned member of the "apple picking gang," showed

up with her telescoping fruit picker (basically a long pole with a basket on the end of it) that grabbed the fruit as we shook it off the tree.

It was obvious that some other scallywags had gotten there before us and literally picked all of the low-hanging fruit, so we had to work a little harder than expected to get apples big enough to make peeling and chopping them worthwhile. Roger and Susy (both having a height advantage over me) were much better at the pole shaking, and with a lot of effort, we were able to fill up three Home Depot buckets.

When we got home, I got to work washing the apples and then used my apple peeler/slicer/corer to prep the fruit for one of my all-time favorite recipes: apple cake.

Apple Cake

Ingredients

2 cups sugar

½ cup oil

2 eggs

4 cups apples, peeled and diced

2 cups flour

2 tsp. baking soda

1 tsp. nutmeg

2 tsp. cinnamon

1 tsp. salt

Directions

1. Preheat your oven to 350°. Grease a 9 x 13-inch pan.

2. Combine the sugar, oil, and eggs in a large bowl, stirring until well mixed, then stir in the apples.

3. In another bowl, sift together the remaining ingredients, then add them to the apples.

4. Stir all ingredients together to form a batter until the flour mixture is thoroughly blended into the wet ingredients. Pour the batter into the greased pan. Bake one hour, or until the cake is golden and set.

12 Servings

This cake is amazing on its own or served with ice cream (or any kind of cream) and strong coffee.

If you are serving the apple cake to guests, time it so it finishes right while they are coming through the door. Half the delight of this cake is the smell wafting through your house.

Slow Your Decor

*P*art of the reason I love homesteading is the emphasis on *home*. I've always wanted a soft place to land, a house to call my own, where we could have people visit and feel comfortable just hanging out.

Similar to the slow food movement (the pushback to fast food), the slow decorating movement is the answer to ordering a household of furniture off Amazon to make your place look "homesteader cute" in a week.

Let me be honest—when we first bought the place, I went a little nuts trying to get the right look for our new mountain Airbnb. When we moved here full-time I realized all that "mountain cute" turned to clutter pretty quickly. I was decorating for other people—how I thought they would want to see a mountain home decorated—and not for us.

So now I am firmly in the "let's take it slow" mode of decorating.

1. When I think about purchasing something, I ask myself the question, "Will I still love this in ten or twenty years?"

2. I have a plan to replace some furniture. Slowly. I have two leather couches I love and am grateful for, but I would not have chosen them myself. I plan on keeping those sofas for the next ten years (because they are well built and beautiful) and choosing to see them as a decorating challenge in my living room (which I am totally up for).

3. I've stopped running to HomeGoods or even Home Depot on a whim. I like to sit with an idea, a plan, or a scheme for more than a minute and really think through what changes I want to make.

A lot of people are talking about the slow decorating movement. Here is my version of slow decorating:

1. I will never be in style, but I will always be in love with my home.

2. Trends are not a part of slow decorating. You will not be buying a room from the Pottery Barn catalog. You will be combining that sturdy indoor/outdoor rug in your kitchen with your grandma's favorite teacup, that cute table runner you picked up on vacation, and the weeds that look like flowers growing on the side of your yard. Somehow, it will all work together. And you will never be out of style because you were never *in* style.

3. You are not in a box. Decorating magazines will no longer be your jam. I decided that my living room is mountain boho and my kitchen is rustic country home with a splash of IKEA. Sorry—there is no $14.99 magazine or section of Pinterest that will work for you. The only way to truly describe our house is "Roger and Kathi," and that works for us. If you thought you were a *Country Living* kind of decorator, it's time to mix it up with a little mid-century.

4. You are not in a rush. Slow decorating cannot happen in a short amount of time. You find the pieces when you find them. Your tastes change and mature.

5. You will have a combination of "good" stuff and "other" stuff. In one interesting article I read about slow decorating, the author said, "Don't ever buy anything that needs to be assembled. That is the sign of a piece of furniture that will not hold up to daily use." But I have not found that to be true. When we bought this house and the owners left a lot of their beautiful furniture behind, we were surprised that one thing they took with them was the

IKEA table. When we asked why they left so much expensive furniture and took that, they told us that it was an IKEA antique that had been brought over from Europe in the 1950s.

6. So much for assembled furniture not holding up.

7. We decided to replace the table with the exact same style that IKEA still carries. If it's held up for seventy years, we figured we could take a gamble on it.

Stocking Up

(and How to Be Ready for the Next Toilet Paper Shortage)

Food management is a much bigger deal for us up here on the mountain than it was in the city, and every year we learn something new.

Last year, when we were snowed in for two weeks in the winter and evacuated for three weeks in the summer, we learned an important lesson: Stock up during the fall for winter in case you get snowed in, but eat down all your food in the summer so that if you have to be gone for a few weeks (and the power is turned off), you don't come home to a freezer so full of rotting food that your first instinct is to duct tape said freezer shut and move houses.

Every summer, we have a "no buy July," when we spend as little as possible on food, clothing, and household items. This is an excellent time for us to eat up everything in our freezer, check the dates on all the canned food, do a deep dive in the pantry, and continue to clean out our fridge.

If you ever feel like you are running out of food, just clean out your fridge. Most of us will find excellent meal ingredients hiding in there.

We always try to go into fall with a fresh freezer, a smaller pantry, and a squeaky-clean fridge.

With all that money you save in July, you'll be able to load up your freezer over the next few months with dairy and meat bought on sale (watch for loss leaders at the supermarket) and extra breads and muffins from your fall baking. Plus, with all the abundance from your garden,

you'll have plenty of frozen marinara sauce, veggies, and berries to hold you over until spring.

Then there is another category of food to take a look at: emergency food.

Most hard-core preppers believe you need at least a year's worth of food to be prepared for anything. I think most people, no matter where you live, need two weeks of food on hand at all times.

On a homestead, I would challenge you to think of having a one- or two-month supply of food on hand.

Now, you have a head start if you're a homesteader. I'm guessing if you are currently homesteading—or planning on it—a garden and some chickens (the gateway homesteading animal) are part of the plan.

So you have fruits, vegetables, and protein already at your fingertips.

Now it's time to fill in with enough long-storage food to last you one to two months. Here are some good ideas for shelf-stable foods to keep on hand.

- *Meats:* canned chicken, tuna, and salmon; ham, dried beef, and sausages

- *Beans:* garbanzo, pinto, black, refried

- *Prepared meals:* soups and stews in cans

- *Fruits:* dried fruits, canned fruits (pineapple, peaches, pears, mandarin oranges)

- *Vegetables:* canned corn, green beans, mushrooms, beets, onions

- *Dairy:* evaporated and condensed milk, coconut milk, powdered milk, powdered cheese, Laughing Cow cheeses (they are shelf-stable)

- *Drinks:* coffee grounds (regular and decaf), tea bags, powdered drink mixes

- *Kitchen staples:* flour, baking soda, baking powder, salt and pepper, white sugar, brown sugar

- *Other items to consider:* peanut butter, jam and jelly, crackers, granola bars, nuts, cereal, popcorn kernels, taco shells, comfort foods like cookies and cake mixes
- *Don't forget your pets:* food (both wet and dry), pet emergency kit (found on Amazon), medication
- *Non-food items to consider:* two-week supply of medications (over-the-counter and prescription), paper towels, garbage bags, toilet paper, cleaning supplies, manual can opener
- *First aid kit:* bandages, gauze, tweezers, antiseptic wipes, scissors, rubber gloves, eye wash, hydrocortisone cream

Fresh First

One of the principles we enact every week is "fresh first." This is especially crucial during times when we might not be able to get to the store.

Since we only go to town once a week on average, our fresh meats and salad vegetables are going to expire before we get to the store again. So we eat all our fresh food at the beginning of the week and then fill in with things that have a longer shelf life right before we go to the store.

This ensures a few things:

1. We are not finding costly but expired food in our fridge.

2. We know at all times what we have in the fridge, bread drawer, and pantry.

3. Meal planning is super easy. The food dictates what day we're eating it.

My most important piece of advice when building up your bulk food pantry? Stock it with things you will actually eat and can prepare with limited resources.

If you love beans and rice, stock it with those. But if the thought of those foods makes you gag, don't buy the beans and rice—no matter how many lists they show up on.

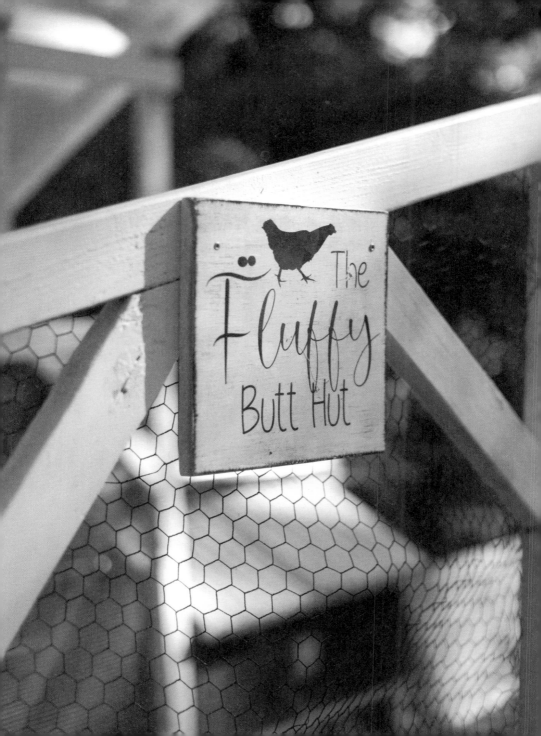

Chickens: The Gateway Farm Animal

Belonging to Facebook chicken groups is a double-edged sword.

The information? Lifesaving (for the chickens, not me). But there is also a lot of judgment in those groups.

Last year, I shared that we barely escaped with our lives after a winter storm put a tree on our roof, knocked out our power, and caused our generator to fail. We were rescued by our neighbors Paul and Julie, and we barely escaped with our dog and cat. We came back the next day so Roger could sled our chickens out. Chickens that had plenty of food and water, a hot water jug to keep them toasty all night, and a shelter to keep them safe.

After barely escaping with our lives, here is the response one chicken owner gave me online: "I wish you had the same regard for your chickens as you do your dog."

Sigh.

Here are three things I wish I could have told her:

1. In our house, chickens and dogs are different. Dogs are pets. Our chickens are more than livestock—we call them petstock. But yeah, it's different.

2. Chickens can survive a night outside with a well-appointed coop and run.

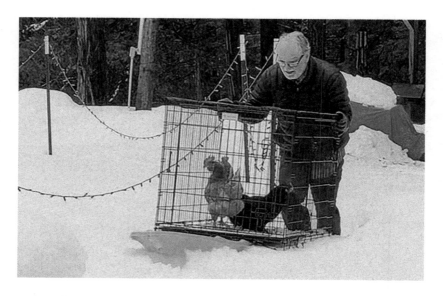

3. Our chickens live a life of luxury. Between their mack daddy coop with an automatic tiny garage door, an enclosed chicken run (plus a chicken play yard), free reign of the yard when we are home to supervise, and a regular stream of fresh blueberries from their grandma (my mom), let me tell you, our chickens are doing just fine.

When you ask for advice or share your experiences online, I promise you there will always be that one person (or a dozen) telling you how you could have done it better.

Welcome to the online world of chicken keeping.

The good news? Most people want to help and are very kind to newbies like me. There was a lot I didn't know about chickens before we got them.

1. When baby chicks fall asleep, they fall over wherever they are standing. One day Roger went to check on the babies and found what looked like a tiny, feathery murder scene. The experience

was life-changing for us both. He went into a full-blown panic, not about mass chicken death but at the prospect of telling me that all those chickens were dead. (I don't tend to handle animal death well.) Fortunately, no one was dead. They were just napping. Hard.

2. Everything comes out of the same hole. Eggs, poop . . . chicken anatomy is amazingly efficient.

3. Chickens can be great flyers. One time when we were evacuated to my mom's house, we lost Bullwinkle for about an hour and a half. Terrified because Mom's backyard abutted a wildlife preserve (where some of the wildlife are coyotes), we were shocked

and relieved to find that little Bully had traveled a block and a half to find some shade under a tree in an unsuspecting neighbor's yard. (The next time someone asks you why the chicken crossed the road, tell them it was for some shade and a little adventure.)

4. Chickens are great compost helpers. In our chicken run, we use pine shavings. I "turn" those pine shavings once a week and add fresh, clean shavings to the bed. I repeat this process for a couple of months, and then I scoop out the shavings to use as mulch for all our plants. I put fresh shavings in their run and start the process all over again. In their coop we have laid the floor with sand, so it's more like a giant sandbox and I can just clean it out and throw the dirty sand away. Think of it as a giant cat box. Chicken manure is sold at the fanciest garden stores around here for a premium. Our girls make more of it than we will ever need.

5. Chickens love a good dust bath. The girls dig holes in the sunniest patch of our property (out by the woodshed), climb into the hole, roll around, and use their wings to throw dust onto their backs. After those baths, they will walk around and leave a dust trail, much like a feathered Pigpen from the *Peanuts* cartoon.

6. Chickens will eat almost anything. Their favorite snacks are blueberries, corn, any bread product, and . . . chicken. (Yes, it's safe to feed them chicken. And weird. Very weird.)

7. Chickens can have an identity crisis. Our girl Pepper has all the qualities of a rooster (protector, crows when someone else lays an egg) without all the hormonal moodiness that roosters are famous for. Apparently this often happens when there isn't an actual rooster on the property; one of the girls will step up to take the role.

8. Roosters can be real jerks. Or they can be delightful gentlemen. We wanted to get a rooster to round out our flock, even though

so many people warned us not to. Finally we took a chance when a neighbor had a second rooster they needed to get rid of (having more than one rooster is a problem because two roosters will fight over their "ladies"). We adopted Jack Jack, terrified we might get the jerk instead of the gentleman. Fortunately, Jack Jack is the best kind of rooster: He calls his ladies over for treats, makes a whooping noise if he feels like a hawk is getting too close to the flock, does a beak count every so often to make sure that all the girls are accounted for, and will break up the occasional girl fight.

Every idiom you've heard about chickens is based in reality. Here are a few of my favorites:

HOMESTEADING PRINCIPLE
The Humbled Homesteader

No project will humble you more than taking on the life of a homesteader. When you go in knowing that you don't know everything (but are willing to learn), it makes it a lot easier to keep going.

It's good to remember that there is a whole host of people who have nothing better to do than to let you know how they would do things better. Like the woman online who tried to shame us for leaving our chickens safe overnight after barely escaping ourselves.

Being criticized has only made me stronger and given me more resolve to think through the priorities we embody and live by here on the mountain. Humbling will do the exact opposite of what the commenter intended—it will make you stronger.

"Pecking order." It's a real thing. When we had four chickens, Cheddar was the boss and Truffles was second in command. When Truffles died and we got two new chickens, Rocky and Bullwinkle, everything changed up. Now it was Brie who was bossing everyone around, Pepper was second in command, then came Cheddar and Bullwinkle, with Rocky now definitely taking up the rear. Rocky has an excellent life—all our chickens do—but Roger still feels badly that Rocky sometimes gets picked on by the other chickens. (They'll try to pull a feather out or chase her away from treats.) So my husband, being a natural caretaker, will often sneak Rocky some treats. When the other chickens aren't listening, he will whisper to her, "You're my favorite."

"All cooped up." Our chickens sleep in a coop. It's a predator-proof, high-tech coop with a cement brick floor, full walls for the sides, and a locking roof. But God forbid they have to wait one extra minute to be let into their run. They need to be safe inside their coop during the night, but they are always dying to get out in the morning. Fortunately, Roger installed an automatic door that goes up and down at the same times morning and night. We do adjust it for the seasons.

"Going home to roost." Our chickens know when it is getting dark and "put themselves up" every night, even when they are free-ranging all over our mountain. Only one time have any of them missed curfew. Brie got locked out one night when we thought she had already put herself to bed. Boy, were we surprised when we were watching a *Superstore* rerun and heard a tapping on our carport window. Where we live, you never want to hear a tapping on your window at night.

"Birds of a feather." When we first got the chickens, I was shocked to see that the two ISA Brown chickens hung out together and the two black Australorps did the same. Did they know they were related? I have no idea, but I was very grateful that when Truffles died, Cheddar and Brie decided to let Pepper into their girl gang.

The only idiom that isn't true is that chickens are "chicken." Chickens are fearless when it comes to fighting back other chickens—or dogs. Especially if a treat is involved.

Interpretive Vegetable Soup

I love vegetable soup. Love. It.

It is the perfect "I don't live near a store" soup. You can reverse-engineer vegetable soup. There is no stifling "you must have these ingredients" when you are making soup. It is pretty much an anything goes kind of endeavor. Any vegetables you have on hand or happen to be growing in your garden are fair game for this soup.

Veggie soup isn't snobby. Really want some corn in your soup, but all you have is the canned kind and you've watched enough Food Network to know that canned veggies are as close to sacrilege as a home cook can get?

I'm here to set you free.

Canned or frozen vegetables in your soup will work just fine. It is so much more about how you season your soup than it is about whether your ingredients came from the freezer, the pantry, or the crisper in your fridge.

I love canned corn in my vegetable soup. It tastes great, gives a little extra crunch, and holds up well if you decide to freeze some leftovers.

Speaking of freezing, freezing leftover veggie soup is a great way to create a stash of yummy, wholesome soup you can use as homesteader fast food. All you have to do is pull it from the freezer the day before, let it defrost, and then heat it up. Easier than driving through Taco Bell and, if you do it right, a lot tastier!

Those veggies that are looking a little tired? They are begging to become vegetable soup.

This is my "interpretive" guide to leftover vegetable soup. I don't believe I've ever bought vegetables for a soup. More likely, "shopping me" has wildly overestimated how much time "cooking me" has had to chop and dice veggies that week, and that sad bin of wilted veggies has now volunteered as tribute.

Interpretive Vegetable Soup

Ingredients

There are a few nonnegotiables when making soup.

Stock: I like to use a chicken or vegetable stock, but I've also used beef broth or even tomato juice.

Oil: Olive oil and butter are the clear winners here, but I've used vegetable oil in a pinch.

Salt, pepper, herbs, and other spices

Vegetables: I like to chop all my vegetables into about one-inch pieces, keeping everything uniform so they cook quickly and evenly.

Directions

1. Cut up the aromatics—onions, garlic, and some fresh herbs. If you have celery, you can throw it in at this point. Start sautéing the aromatics in the oil or butter. Let them get a little color to enhance the taste.

2. Put in the heartier veggies next—carrots, potatoes, turnips, and other root veggies. Give them a few extra minutes to cook. This would also be the time to add canned beans if you'd like.

3. Now start adding in other vegetables: squash, zucchini, tomatoes, green beans, asparagus, eggplant, mushrooms. Let these get a little color as well. (I've been known to use canned vegetables when I don't have what I want. Canned tomatoes, corn, and green beans are all a great addition to your interpretive soup.)

4. If you have some leftover meat in the fridge and would like to add that, now is the time. This is also the point I would add things like spinach, cabbage, and any other "thin" additions.

5. Now it's time to cover the vegetables with your broth, add your dried herbs and spices, and simmer away.

When choosing the optional but awesome spices you can use, I like to stick with one flavor profile. Here are just a few to explore:

Mexican—cumin, chili powder, peppers, oregano, garlic

Italian—basil, Italian herb blend, oregano

Indian—tandoori spices, garam masala, curry, yogurt, coconut milk, tamarind, cardamom, cumin, coriander, cilantro, fennel, garlic, saffron

Fresh herbs also add great flavor. And remember, they are easy to grow in your kitchen windowsill.

This is where your creativity comes in. Taste and adjust as you go along. I'm usually a five-spoon taster, so I just put those by my pot and adjust until the soup tastes amazing.

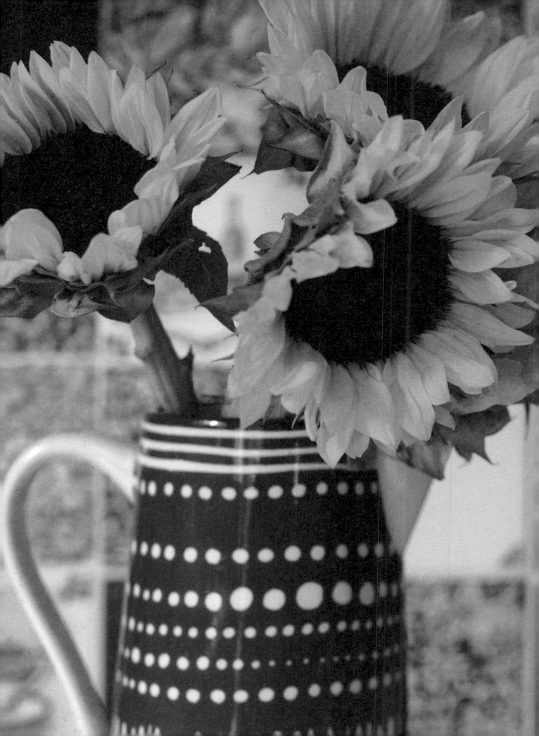

❊ THE NEXT WINTER ❊

Winter has never been one of my favorite seasons, coming in dead third (only beating out hot and muggy summer). While fall and spring are still my favorites, winter is rising in my esteem every year.

Winter not only comes with some forced rest (you aren't doing much building or gardening when there is snow on the ground) but also is a great time to reflect on all the improvements you've made to your life and your homestead over the past year.

As I look back on our past year, I consider some of our projects: installing new floors upstairs, planting our first giant in-ground garden, growing our chicken flock, tiling our kitchen, redoing our bathroom, felling eleven giant trees to make our property safer and more usable, repairing our roof and walls after a tree fell on our house, and dozens of smaller projects too numerous to name.

We have improved our house and the land, and we've learned what we can do and what we are capable of. (Thankfully, we've also learned what our limitations are and when we need help.)

Don't forget to take that pause on your homesteading journey. Give yourself time to celebrate all you've done and reflect on all you've learned.

Even with all we've accomplished, after five years we still feel like we are at the beginning of our homesteading journey. There is so much more to learn to do for ourselves. Some of it we will learn about and do. Other things we will learn about and decide that they are not for us (butchering our own meat and doing our own electrical work come to mind). But that's the beautiful thing: We have the power of choosing what we'd like to do, and that is about as deep of a homesteading principle as I can imagine.

Homesteader Holiday

When we lived in San Jose and Roger took his vacation days, we would get so excited to take a trip up or down the coast, head toward Canada to go exploring, or drive to Disneyland and spend way too much money.

We still go on vacations, but now it's to see family or attend a wedding. Any extra time we have is spent on a "homesteader holiday." That is our term for taking a week off work to do a few big projects that need to be done around the house and the property. Here are some of the projects that have happened during our homesteader holidays:

- building the chicken coop
- building the greenhouse
- sanding the deck
- tiling the kitchen
- cleaning out the closets
- cleaning out the garage
- cleaning the carpets

- painting outdoor furniture
- building a watering system
- creating a fire break around our house
- planting the garden
- prepping wood for winter
- cutting down trees

And here are some of our recommendations for your homesteader holidays:

1. Schedule those weeks on your calendar far in advance. You will never have a week magically pop up when you have nothing to do. We have to plan our lives around our homesteader holidays and treat them like any other vacation.

2. Once that week is on the calendar, guard it with your life. Everything will try to convince you that you don't need the whole week and that you can spend some time having people over to the house or going to town. Don't do it. Protect that week like it's an all-expenses-paid trip to Greece.

3. Decide in advance which projects you will work on. Roger will usually take on one big outdoor project, and I will choose one of our indoor projects to get done. Roger will plan his project, create his materials list, determine whether he needs to call anyone else to help him, make a budget, and create a timeline. (Same with me, but I'll be honest. I may not be quite as detailed in my planning as my husband, who has been an engineer for more than thirty years.)

4. Plan to go to town once during the week. You will for sure forget one doodad or whozit that the entire project hinges on. (And yes, sometimes that thing is literally a hinge.) Schedule the day to go into town, and create a list of things you want or need to complete your project. (Avoid going into town on Monday afternoon just after you discover you're missing the valve you need. Trust me, if you keep working, you'll realize you also need something else (besides the seventy tools that are currently in your garage), and you don't want to make multiple trips.

5. Organize the rest of your life so you can focus on your special projects. I do a big grocery shopping trip and prepare a bunch of meals the week before our homesteader holiday. Taking care of

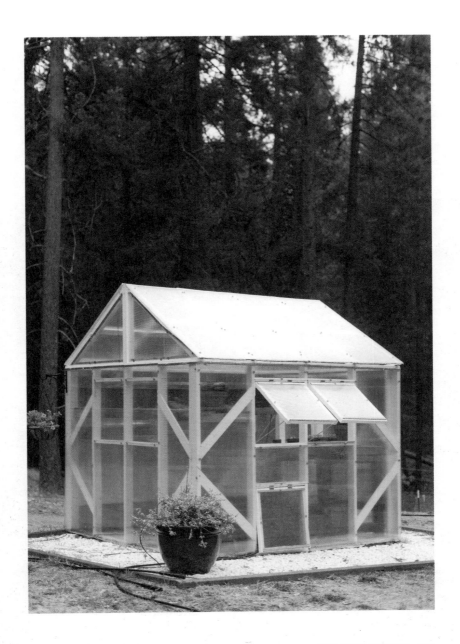

your future self is one of my favorite concepts.

Food: I plan out all the meals for the week, and each evening I check what is on the schedule for the next day's menu and prep it the night before. This might mean taking things out of the freezer, putting all the ingredients in the Instant Pot or slow cooker the night before, or making a marinade for some meat. I also buy a couple of prepared meals from Trader Joe's or Costco that I can just stick in the oven or the microwave.

Going into town: Wednesday is our day to stop projects and pick up materials from Lowe's or Home Depot, so we usually take advantage of extra services in town. We'll drop off a load at the dump (projects have a lot of materials that are no longer good, but we will always see if there is something valuable that someone might want before we just dump it). And we'll get dinner out, so there is at least one meal that week I have exactly no hand in preparing.

Laundry: I wash every piece of laundry before the homesteader holiday starts. This is for three big reasons: First, I am a big believer that having the right clothes will make me better at completing household projects. The best work clothes are comfortable, worn in, and not too nice to be splattered on. It's science. Second, I sweat more working on projects around the house than when working at a computer. I like to be able to change. Often. Third, I like knowing that I have a week's worth of clean underwear ready and waiting to go. I don't want to have to do laundry when I really want to be using my one homesteader holiday week to do things that require more focus.

6. Make sure you are taking care of yourself during the week. Before your holiday, stock up on things like sunscreen, bug repellant, gloves (have a large supply of work, gardening, and latex gloves), Tylenol, snacks, coffee, and Salonpas Pain Relieving Patches (trust me).

I promise you—you will never regret taking a homesteader holiday. We plan ours to get ready for our two most extreme times of the year: summer and winter. We have a long list of must-do items for both of those seasons, and we don't want to skip any of them. Plus, it's great to have a week without any other tasks. It helps you remember why you chose this lifestyle in the first place.

At this point in our homesteading journey, we look forward to our homesteader holiday as much as we do a vacation visiting faraway family. The sense of accomplishment can't be matched in any other way.

Raclette

This is a word that means many things to me:

A cheese.

An appliance.

A small scraper.

A dinner.

And everything wonderful.

Okay, I know that this dish requires buying a special appliance. But, friend? It is so worth it.

Raclette is a traditional meal made using Alpine cheese, and it is eaten around a raclette set—a tabletop grill with little trays to melt the cheese into.

Add lots of lovely starches, meats, veggies, and more for the ultimate group meal where you gather around the table, cooking cheeses and meat, passing platters of veggies and garnishes. You cannot help but have a great time while eating raclette.

(And shhh . . . It's a meal that can be prepped ahead and requires no cooking the day of. It is perfect when you've been cooking for days for a large group and you just want to have a night off.)

Plus, if you have people with different food tolerances, raclette can be customized for anyone. Everyone can enjoy different versions of the same meal!

This is not a two-person meal. This is a large-group meal for people who love each other, or for when you want to introduce friends who might not have a lot in common but are all great people who should get to know each other. There is a lot of grilling for each other and having someone mind your melted cheese. The shared new experience quickly turns strangers into friends.

Required Ingredients

3 to 7 oz. raclette cheese per person, sliced to fit the small trays under the raclette grill. (We find this at Trader Joe's and at some of the fancier stores from around November through February, and we've even found it on Amazon.)

4 to 6 new potatoes per person, boiled with the skins on.
(You have better things to do with your life than peel tiny potatoes.)

Optional Ingredients

Everything else is what you like or have on hand. That's the beauty of this meal—you get to make it what you love. Here are some ideas:

bacon

beef fillet, thickly sliced

pork sausage

zucchini, thickly sliced

mushrooms

grape tomatoes

white pearl onions

bell peppers, thickly sliced

cornichons or pickled gherkins (traditional dinners call for sweet pickles, but we only use dill)

pickled baby corn

asparagus

crusty, hearty bread

barbecue sauce or ketchup (I have found this to be a game changer)

Directions

1. Turn the raclette grill on to medium-high heat.

2. If you are using bacon, place the slices on the grill plate and cook to your liking.

3. Use the bacon fat to cook the other ingredients. (If you are not using bacon, simply brush the grill plate with some olive oil.)

4. Place some meat and vegetables on the hot grill plate. (When we have vegetarians or vegans visiting, we use two grills. You could even just use a tabletop skillet for the veggies and the raclette skillet for the cheese and meat.)

5. While the meat and vegetables are cooking on the grill plate, place slices of raclette cheese on the small trays and put them under the heating element.

6. Slice or smash the potatoes on your plate. Scrape the melted raclette cheese out of the tray and serve it over the warm potatoes. It is also common to place the melted cheese over the cooked vegetables. Some people even put slices of potatoes into the handled trays so that the cheese melts directly on top.

8 servings

This is a warm, hearty dinner that is a universal hit at our house and with our guests.

If you want to keep the whole meal on the tabletop, you can even use it to prepare dessert. Just clean off the grill and roast marshmallows over it to create tabletop s'mores. (Is there a better way to end a meal than with chocolate and marshmallows?)

Balance Planning with Improvising

Being a homesteader, there is a huge push and pull between military-precision planning and improvising on the fly.

For most of my adult life, I have fought the good fight in order to just get dinner on the table. A meal plan is great, but I spend even more of my time trying to figure out what I'm going to make with the leftovers in the fridge before they go bad.

Like today. Yes, I need to make a shopping list for when I go into town on Wednesday, but I also need to use up the leftover squash, Greek yogurt, Costco chicken, and mashed potatoes I have sitting in my fridge. I've decided to make chicken Greek yogurt salad with squash and corn fritters for dinner tonight, and then a chicken and vegetable shepherd's pie for dinner on Tuesday.

That's how you know you've reached the next level in your homesteading kitchen game—when you're able to clean out the fridge and make a meal that looks like it was on purpose.

When you only drive into town once or twice a week, and you're on a budget because you'd rather spend your money on an outdoor play yard for the chickens than on food to replace what has spoiled, you have to know how to, as Ross Geller says, "Pivot!"

For example, say all spring and summer you've been looking for ways to use up all the eggs your girls have been laying. You've been making scrambles, quiches, cakes, and more.

But then you're in the dead of winter and you haven't bought eggs in ten months, and now that it's time to make an apple cake, your girls have decided they are on strike and are no longer laying.

It's time to improvise. Here are some things you can substitute for eggs in baking, depending on the recipe:

mashed banana
unsweetened applesauce
yogurt
ground flaxseed

Here are some things to always have on hand for use-it-up meals:

Eggs: You can make anything into breakfast if you put an egg on it. Leftover cooked potatoes? Cut up those taters, bind them with an egg, and you have hash browns. Or many of the hippest restaurants will add an egg on top of anything (pasta, gourmet hamburgers, steak, cassoulet) and charge an extra five dollars for it.

Tortillas: A couple times a month, I splurge and buy a party tray of cooked shrimp at Costco. I love to do this when I'm trying to eat healthfully and can just swing by the fridge and grab a couple of shrimp for a quick snack. It makes me super happy. But the shrimp only last a few days, and I need a way to use them up. So I sauté some onions, throw in some taco seasoning, and warm up the chopped shrimp. Then I clean out the pan, warm a tortilla, put a little cheese on it, and fill it with the shrimp and onion mix. That right there is a restaurant-quality quesadilla with seven minutes of prep. I top it with a homemade mixture of salsa and Greek yogurt, and it is amazing.

Other tortilla use-it-up meal strategies:

- Any protein or sautéed veggies can be made into a quesadilla.

- If you are out of chips, just fry or toast a tortilla.

- Spread an almost-too-ripe banana and a thin layer of peanut butter on a tortilla.

- Make cinnamon sugar tortilla chips. All you need is a pizza cutter and a little imagination. These are delightful served on their own or peeking out of a bowl of ice cream or frozen yogurt.

How to Season Your House

I love to follow decorators on Pinterest and Instagram, but I've come to realize that their decorative ideas don't always translate to a homestead.

One designer I follow uses different dishes for winter, spring, and fall. When you're storing as much chicken feed, emergency food, and power tools as a homesteader does, an extra bin of seasonal dishes just doesn't make the cut.

But with the seasons here being so extreme (we wear sweaters for warmth, not just to be cute), I like to reflect those seasons in the house as well.

Plus, can we just admit, as much time as we're spending on the hard work of homesteading, it can be really fun to pay attention to the inside of the house as well.

Downstairs is where I tend to change up my decor most. In the kitchen, my base colors are blue and white, and in the living room, my base colors are black and cream. In each of those rooms, my pop of color is red.

I have a tote for each season except winter, for which I have about a dozen totes. (My husband is super into Christmas.) Each box has things I love but don't need to have out all the time. Winter is when I make the biggest change to the interior of the house. I love to layer the house in all things cozy. As we go into warmer months, I start to peel back the layers and lighten up the house.

The "one tote" rule keeps me from going country crazy with all my decor, forces me to figure out how much impact I can get with limited tote space, and keeps me from hoarding a bunch of stuff.

Here are some of the things I have in each tote:

1. *Throw pillow covers*: When trying to save space, this is my number one trick. I have a few plain pillow forms, and I just switch out the covers each season. Pillows can take up a lot of space, but covers take up almost none at all.

2. *Table runners*: I leave out my table runners day to day and don't take them off unless I am throwing a party and want to use a specific tablecloth.

3. *Hand towels*: I have now become the "Chicken and Cheese" lady in my circle of friends (because I'm all about loving the chickens and eating the cheese) and have had friends and family gift me hand towels in both those categories. I divide them into seasons and overlay the most neutral ones with some Christmas-themed towels for the winter.

4. *Quilts*: My mom is an accomplished quilter, and we probably have about two dozen of her quilts here at the house. There are some in the bedrooms that we leave out all year, but the rest we rotate through the seasons.

5. *The occasional meaningful knickknack*: I have some delightful tchotchkes that people I love have given me and that I adore. But I've noticed that when I have things out year-round, they become part of the background noise. As much as I would love to keep these items out all the time, my house would explode if I did. So now I rotate them with the seasons. For example, when my friend Susy gave me two handmade dolls in traditional dress from a local native American tribe, I put them with my fall collection. Every fall, I pull those dolls out and display them for all to see. (And they make me happy every time I unpack them.)

6. *Candles, soaps, and room fresheners:* I love to switch up all of these scented items, and sometimes I'll pull out the fall-inspired cranberry-scented candles just to *will* fall into existence when I deem that summer has overstayed her welcome. In spring I like floral scents—I personally love lavender everywhere in the house. Citrus is my go-to summer scent. One of my new favorites is grapefruit, but I love lemon, lime, and orange as well. In fall it's apples and cranberries, and winter features pine.

Each season also has its own unique items. I have a lot of flowers and birds on pillows and quilts that I love to show off in the spring.

Summer is when we pull out all the red, white, and blue in every capacity. My birthday is June 14, Flag Day, so I consider this the official start to all things summer.

Fall is when the red-and-black buffalo plaid makes an appearance and we start to cozy up the house with a lot of extra fleece blankets. (We call them "dog catchers" because Moose will sit on anyone who is using a fleece blanket.) I also have a red and cream table runner that looks like chunky macramé fabric. I got it at a wonderful market called Provisions (is that not the best name for a store?) when we traveled to Eugene, Oregon.

In winter we spend a whole day bringing everything down from the attic that is related to winter and Christmas. We keep everything Christmas up until Epiphany (January 6). Then we pare it down to just the winter base of the decor.

Bonus! Living in the forest means we can have as many Christmas trees as we'd like without the $120 price tag we were paying in Silicon Valley.

So half of our dozen (or more) Christmas boxes are just for the three trees that Roger wants in our house.

The things we do for love.

Is any of this required to be an excellent homesteader? Obviously not.

But we spend so much time around here keeping things functioning that it feels great to spend a little time making the house feel special.

How to Not Be Afraid of Your Cast-Iron Pan

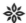

There is nothing (and I mean nothing) that will make you feel like a homesteader more than cooking with a well-seasoned cast-iron skillet.

When we bought the Red House, the owners left not only most of their furniture but also all of their plates, silverware, glasses, mugs, and most importantly, an impressive array of cast-iron wear. Everything from deep pans for frying a chicken to flat iron griddles for cooking up pancakes for a crew.

I think the number one thing that keeps people from using their cast iron is knowing how to prepare it and care for it.

Don't be thrown off by the ancient tales of complex care for your cast iron. Just develop a simple routine, and it will serve you for generations to come.

How to Season a Cast-Iron Skillet

Before you put one piece of steak in that skillet, you need to season that girl up.

1. Scrub the skillet in hot, soapy water. (This is the last time soap will touch your skillet. Ever.)

2. Dry it thoroughly with a towel.

3. Grab some shortening or veggie oil. Using a paper towel, cover the skillet with a thin layer of oil or shortening.

4. Put a large cookie sheet on the bottom rack of your oven to catch any drips.

5. Place your skillet upside down on the top rack of your oven.

6. Bake the skillet for one hour at 350 degrees. When the timer dings, turn off your oven, but let the skillet stay in there until the oven has cooled and you can pull the skillet out.

How to Clean a Cast-Iron Skillet

1. After cooking something amazing in your skillet, clean it while it's still warm.

2. Add hot water and use a sponge or stiff brush for cleaning off food debris.

3. Stuff still stuck on? Scrub it with a paste of three parts baking soda to one part water with a little coarse kosher salt thrown in.

4. Still can't get it clean? Cover the bottom of the pan with water and bring it to a boil on the stove. Then scrape off the crusty bits. I use a stiff spatula so I can really get at it.

5. Dry the skillet. Thoroughly. Rust is the enemy.

6. Using a paper towel, sponge some vegetable oil onto the skillet to coat the bottom and sides of the cooking surface. Store it in a dry place.

Two-Day Cast-Iron Fried Chicken

Ingredients

- 2 T. kosher salt, divided
- 2 tsp. plus 1 T. freshly ground black pepper
- 2 tsp. paprika
- ¾ tsp. cayenne pepper

- 1 tsp. garlic powder
- 1 tsp. onion powder
- 1 (3 to 4 lb.) chicken cut into 10 pieces, backbone and wing tips removed

- 1 cup buttermilk
- 1 large egg
- 3 cups all-purpose flour
- 1 T. cornstarch
- peanut oil (for frying)

Directions

1. In a small bowl, whisk 1 tablespoon of salt and 2 teaspoons of black pepper with the paprika, cayenne, garlic powder, and onion powder. Season the chicken with all those yummy spices. Place the chicken in a bowl, cover it, and chill overnight.

2. Let the chicken stand, covered, at room temperature for 1 hour. While letting the chicken get to room temperature, whisk the buttermilk, egg, and ½ cup of water in a medium bowl. In a 2-inch-deep 9 x 13-inch baking dish, whisk the flour, cornstarch, remaining tablespoon of salt, and remaining tablespoon of pepper.

3. Pour peanut oil into a 10- to 12-inch cast-iron skillet to the depth of three-quarters of an inch. Place a deep-fry thermometer in the oil with the bulb submerged. Heat the skillet over medium-high heat until the thermometer registers 350 degrees. Meanwhile, place a wire rack inside a large, rimmed baking sheet.

4. Working with one piece at a time (I use a pair of tongs), dip the chicken in the buttermilk mixture, allowing excess to drip back into the bowl. Then dredge it in the flour mixture, tapping the chicken against the bowl to shake off any excess. Put 4 or 5 pieces of chicken in the skillet. Fry the chicken, turning it with a clean pair of tongs every 1 or 2 minutes and keeping the heat of the oil around 325 degrees, until the skin is a deep golden brown and an instant-read thermometer inserted into the thickest part of chicken registers 165 degrees. (This takes me about 10 minutes for wings and 12 minutes for thighs, legs, and breasts).

5. Using tongs, remove the chicken from the skillet, allowing excess oil to drip back into the skillet. Transfer the cooked chicken to the prepared rack on the rimmed baking sheet.

6. Repeat with the remaining chicken pieces; let cool for at least 10 minutes before serving.

4 Servings

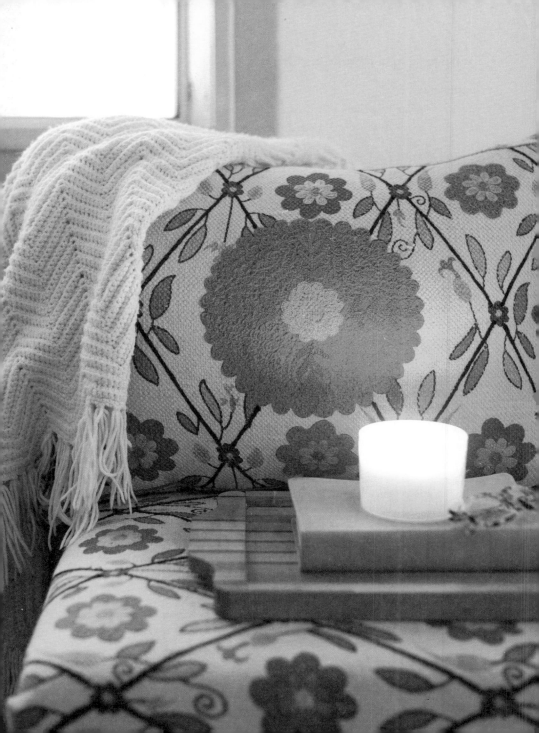

Finding Your Homesteader Rhythm

Before we moved to the Red House, I used to take some time each morning to plan my day. I no longer have to do that because the mountain plans my day for me.

No more jumping out of bed on a cold January morning to immediately plop down and read my Bible or hop on the computer to get words on the page or answer emails. If I want my hands to be able to move in the cold, I need to get the fire going in our woodburning stove so we can heat up the entire house.

I used to think starting a fire meant throwing a few logs in the fireplace and lighting a match, but getting a good fire roaring takes time, attention, and patience. So you'd better have prepped your coffee the night before if you want some for the twenty to thirty minutes you'll be attending the fire. And don't you try to multitask. The fire will know and will immediately die from a lack of attention.

For at least half the year, the first thirty minutes of my day are always planned out: drinking coffee and building the fire.

That means our last thirty minutes of the day are also planned out: bringing in firewood and setting up the coffeepot for the morning.

We are also very aware of the power we use up here on the mountain. We set up our big appliances (washing machine, dryer, dishwasher) to run while we're sleeping, when power is the cheapest.

We have a whole list of things that need to be done in the morning and in the evening.

Morning

- Let the dog out
- Fix coffee
- Start a fire
- Unload the dishwasher
- Fold clothes and put them away
- Make breakfast
- Let the chickens out
- Clean the chicken coop and freshen their water and food (much easier to do when you don't have five feathered supervisors)
- Plan lunch and dinner for the day
- Spend some time with God and coffee

Evening

- Make dinner
- Feed the animals
- Do the dishes
- Clean the kitchen
- Set up coffee for the next morning
- Fold clothes and put them away (or more likely, just take them from the dryer and put them in the bathroom for the next morning's shower—the chickens don't care if I wore the same outfit on Monday and Wednesday)
- Bring in firewood

- Let the dog outside
- Lock up the chickens
- Close up the barn

I used to resist the rhythm. I would want to skip over parts or try to find ways to make it go faster. But I've come to learn that if I give in to the mountain schedule, the mountain rewards me with a sense of peace and accomplishment.

In the city, for the last few years we lived there, I had a terrible problem with insomnia. I had the worst time not just falling asleep but staying asleep. Here on the mountain, my sleep issues have magically disappeared. Oh sure, sometimes I'll wake up because of a windstorm or a random animal deciding that tonight is the night they are going to make a move on their girlfriend (and announce it to the rest of the forest). But for the most part, I drop into bed around eight p.m. and watch some old reruns like *Frasier* (did I mention we are party animals around here?). I don't wake up until around four thirty or five a.m. to start my day.

And as much as I would like to credit mountain magic (and charge more for the people who stay here for retreats, because I've discovered that people will spend a lot of money on a good night's sleep), what I'm beginning to understand is that it's not about all the work I'm doing up here. It's about respecting the rhythm that is best for where I live and for me.

How to Create a Homesteader Rhythm

Much of a homesteader's work depends on the seasons. Most of our outdoor work has to take place as spring is warming us up and fall is cooling us down. In the summer, we usually have a couple of hours in the morning to work before it gets too hot to function.

Rest Day

We take our Sabbath very seriously around here—not because we are legalistic but because we are tired.

From sundown Saturday until sundown Sunday, we don't plan on doing any real work. All of that is planned for before or after Sabbath.

Since we are resting on Sunday, this means the chores to be done, the meals to be prepared, the laundry to be folded, and the dishes to be washed all have to be done on Saturday. So that is what we spend most of Saturday doing: preparing to rest on Sunday. But Saturday also prepares us for most of the rest of the week.

Plan Your Week

Our "computer jobs," our "house jobs," and our "outdoor jobs" make for long days. Saturday used to be our catch-up day. But now, because we value good mental health and our sanity, we have reframed Saturday into our "work ahead" day. Saturday is the day that we prepare.

But what work needs to be done on Saturday? What meals will I be making? What chores will Roger be outside working on? That all must be determined long before Saturday. And that's why we work backward.

Monday

The beginning of the week is all about establishing goals of what I want to get done for the rest of the week. This week I have a bunch of business work to check off, but I also want to prep the greenhouse and planter boxes for when it's time to plant. Plus, I want to start our indoor seeds so I actually have something to plant when it's warm enough.

Monday is also the night I place online orders for anything we want to pick up in town on Wednesday.

Knowing on Monday what I want to get done for the rest of the week doesn't keep me from having some downtime to read a book or watch my favorite TV shows. It just ensures I'm staying on task while I do it. Mondays are all about setting the tone for the rest of the week so we can take Sunday off and enjoy the literal fruits (and vegetables) of our labors.

Tuesday

Tuesday is the day I am most focused on my writing and coaching

business. I still do things to keep the house and property running, but most of my day is spent at my computer.

The most important thing you will do as a homesteader is figure out your way of keeping track of everything you need to buy, everything you want to accomplish, and everything you need to remember.

I make lists in a spiral notebook and on an app on my phone.

I always need to take certain things with me on our weekly trip into town. I put everything except the Blue Ice in the car on Tuesday, with a note to remind me to pack the Blue Ice on Wednesday morning. (A note sounds fancy. I put a piece of blue painter's tape on the garage door to remind me to pack the frozen Blue Ice.)

- Cooler and Blue Ice

- Grocery bags, checks to deposit, and packages to mail

- Things that need to be returned (Become an expert at returning things—this will save you time, money, and hassle. When you're not sure if you need 1-inch grommets or 1.5-inch grommets, you can buy both, but only if you have a plan to return the ones you don't need.)

- Measurements for anything to buy at a home improvement store (Because, trust me, you don't want to have to go back into town to get anything.)

I put in a full day on Tuesdays for my job, but during the early morning, the evening, and the bits in between, I get ready for our trip into town.

Wednesday

Wednesday is our day that we go into town. My mom lives in town, so we head to her house and work until about two p.m. This is also where we have all of our packages delivered because there is only a 25 percent chance that any packages we have shipped to our house will make it. After that, we usually hit a few different places:

- Costco (or our new favorite discovery, Sam's Club, which is like Costco but carries smaller sizes and lets you order ahead and pick up groceries), Trader Joe's, or another grocery store

- Lowe's or Home Depot (for supplies for homesteading projects)

- Target or Walmart (for miscellaneous stuff we need around the

house or things we want in a smaller size than Costco carries)

- Office supply store
- Bank
- Pet store (for our furry animals) and feed store (for our feathered animals)
- Water store (Our water is perfectly safe to drink, but my husband is the Goldilocks of water and needs it to be "just right," so we buy water for drinking and making coffee.)
- Post office (We pick up mail once a week or so, about thirty minutes from our house, on our way back home.)

Thursday

I work longer hours on Thursdays to "make up" for the time we're gone on Wednesdays.

Friday

Fridays are for wrapping up the work week and prepping for the weekend. Sometimes I'll prepare for Saturday—my big cooking day. We will also work long into the evening (remember, we get up at five a.m.) to prep for any home projects so we can hit the ground running on Saturday.

Saturday

Even if we have guests, Saturdays are for getting projects done on the property and cooking for the rest of the coming week.

Sunday

Rest. Worship. Rest some more. Hang out with the people I love.

If homesteading is something you want to do, or you just want to adapt some homesteading principles, creating rhythms in your days, weeks, and seasons is one of the most powerful ways to accomplish a seemingly impossible amount of work while still living in peace and contentment.

HOMESTEADING PRINCIPLE

A Lot of Small Changes Make a Huge Difference

Whether it's controlling the temperature in your house, setting the family food budget, managing a housecleaning routine, or maintaining your garden, you can make a huge difference with a lot of small changes.

Many of those small changes involve establishing new routines. Here are a few small routines we've established that have changed our budget in big ways:

- Reducing our garbage by feeding the chickens, composting, and recycling
- Reducing our gas bill by being strict about going into town just once a week, keeping an updated list of what we need to get done in town, and planning meals and projects ahead of time
- Planning meals and LOOPS (Left Overs On Purpose) to reduce food waste
- Making drinks at home instead of buying containers of iced black tea, iced passionfruit tea, and cold brew coffee
- Drying herbs at home
- Using cloth towels instead of paper towels
- Growing plants from seed

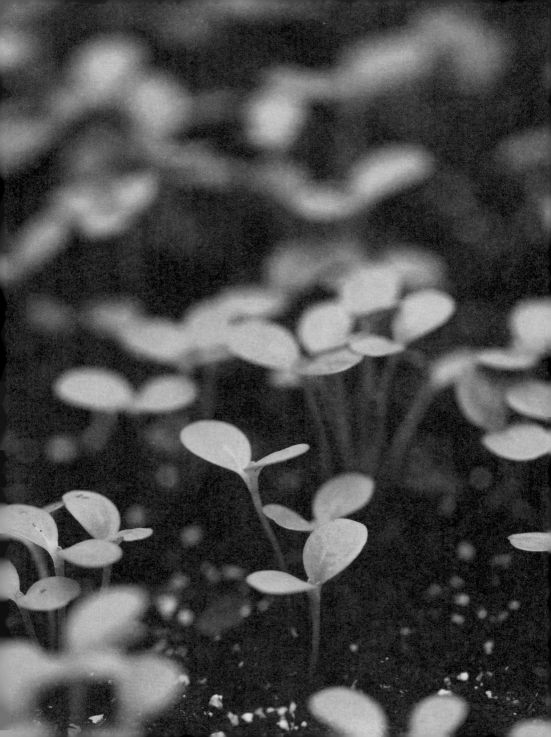

All-Day Beef Stew

I love using my slow cooker in the winter because I'm all for heating up the kitchen when the temperature drops into the thirties. Plus, there is nothing that makes you appreciate a meal more than one you've been smelling all day.

I watch for loss leaders on beef stew meat and stock up, freezing the meat in two-pound packets and then making this stew when the weather gets colder.

I love this stew because I can use the vegetables I have on hand. Don't have russet potatoes? That's fine—I use the baby potatoes that are about to sprout if they aren't eaten soon. Don't have celery in the dead of winter? I leave it out or add some more onions.

And if you love Worcestershire sauce as much as I do, feel free to add a whole tablespoon to give it that extra umph!

Ingredients

- 2 lbs. beef stew meat, cut into 1-inch pieces
- ¼ cup all-purpose flour
- 1 tsp. salt
- 1 tsp. ground black pepper
- 1½ cups beef broth (I like Better Than Bouillon, but canned broth or bouillon cubes added to hot water also work great)
- 4 medium carrots, sliced
- 4 medium potatoes, diced
- 1 medium onion, chopped
- 1 stalk celery, chopped
- 2 tsp. Worcestershire sauce
- 1 tsp. ground paprika
- 1 garlic clove, minced
- 1 large bay leaf

Directions

1. Put the meat in the slow cooker.

2. Mix the flour, salt, and pepper together in a small bowl. Coat the meat with the flour mixture.

3. Add the remaining ingredients and stir to combine.

4. Place the lid on the slow cooker. Cook on low for 8 to 10 hours or on high for 4 to 6 hours, until the beef is tender.

 8 to 12 Servings

This stew is best served with crusty bread out of a big ceramic bowl, directly after coming in from shoveling the snow.

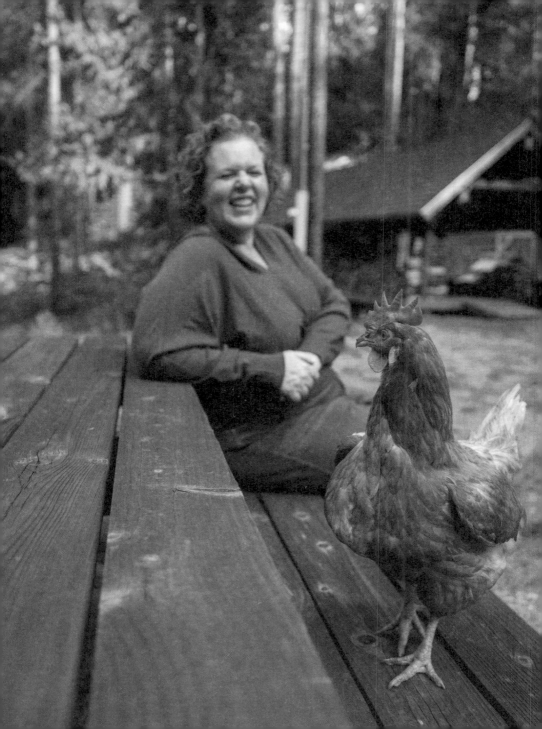

Conclusion

I know there are a lot of different types of people reading this book. There are the tourists in homesteadland who are fascinated with the idea of living off the land and want to read all about it from the comfort of the suburbs.

And I salute you.

It's always productive to learn about how other people live and then see if you could incorporate aspects of that to make your own life better. For years I read about homesteading, never intending to actually do any of the "extreme" stuff. If I could be fascinated by someone else's life, that was good enough for me.

Then there are the readers who are looking for real live "we're about to sell our house in the suburbs and find our own house with 33 acres" tips. Finally, there are those of you who have no intention of doing anything homestead-y but are looking to make a major change in some other area of your life.

I hope that in each case, there has been something here for you. Whether it's a little instruction or inspiration, we can always learn something from others who have taken on a challenge (accidentally or intentionally) and have learned how to navigate it.

I hope that you are emboldened to take your own journey, whether it's to the mountain or your own backyard, to live life on the terms that God and you decide are best for you to live, serve, love others, and grow as a person.

My hope is that I've served you well.

Chocolate Chip Cookies Serves °375

Here's what's cookin'
Recipe from the kitchen of

1/4 C brown sugar
3/4 C butter flavored Crisco
2 T milk
1 T vanilla extract
1 egg
1 3/4 cup flour
1/4 t salt
3/4 t baking soda
1 C chocolate chips

RECIPE INDEX